MAZE THEATER

迷 宮 劇 場 李 子 勳 作 品 集

LEE , TZU-HSUN'S PORTFOLIO

李子勳瞬間記憶連結的美學殿堂

陸蓉之 策展人

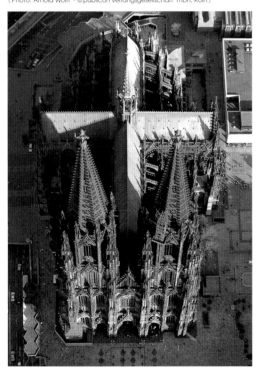

創作〈愛情殿堂〉的參考圖片—科隆教堂俯視圖，德國（攝影：安諾·沃夫）
The reference for creating the "Love Temple"— Bird's-view of the Kölner Dom, Germany
（Photo: Arnold Wolff，©publicon verlagsgesellschaft mbh, Köln）

　　1973 年在臺北出生的李子勳，從小便喜愛藝術，在家人的悉心呵護下，很早就展現他在創作方面異於常人的非凡才華，因此他在高中時代選擇進入臺北著名的復興美工學校，在那裡獲得最嚴格的基礎訓練，但是他從來不以此為滿足，又自行在校外安排各種進修的途徑。李子勳在學校畢業後像其他的年輕男孩一樣進入軍旅服兵役，之後在因緣際會的奇妙機緣引領下，他踏上了遠離家鄉赴德國留學的漫漫長路，赴德進修對他一生的藝術事業起了關鍵性的影響作用。如今李子勳已經從德國杜塞道夫藝術學院畢業，目前以專業藝術家的身份旅居德國當代藝術的重鎮科隆，專注於大型作品的創作及跨領域多媒體之研究工作。

　　李子勳的藝術，很難以媒材的分類方式予以定位，一直想要成為建築師的李子勳，他的作品很自然地以空間作為他的表現舞臺，大型裝置成為他最愛的選擇。他在作品中所呈現的虛擬的藝術世界，和他戲劇化的真實人生，一向有著非常緊密的關係，其中綿密糾纏的牽連與呼應，就像一場接連一場上演的默劇，只有演員才是主場，可以完全沒有喧嘩的舞臺或炫目的燈光特效；只有守在近距離觀看的人們，可以獲悉他在沈默中釋放的深沈悲傷或強烈喜樂，其間所形成的強烈對比張力，不但牽動著他每一根纖細敏感的神經，也反映了他靜默和不喜張揚的個性；在他蒼白的皮膚表層下，情感在激烈地抖動躍舞著，同時也誘使觀者想要更進一步靠近他的作品，而無可避免地產生了心理上的互動。李子勳自願扮演著一個默劇演員的角色，當然也就沒有人能夠聽到他聲嘶力竭的吶喊，但是，站在他的作品前，透過他精妙機智、細緻入微的詮釋，觀者總是可以深刻地感受到他發自生命最深層的豐沛情感，充滿了生、死、愛、恨的各種掙扎與糾纏，隱藏在絢麗多姿的色彩與造型美學中。他將內心深處的夢幻場景，以抽絲剝繭的方式，苦行僧式地耐心以手工打造每一個零件的細部，最後組建成壯觀的空間裝置，將他個人的信念昇華為普世皆可分享的精神聖殿。這種幾近於嘔心瀝血的奮力創作過程，絕對不是一般生產線式的藝術品加工者所能理解或想像的。

　　出國之前的李子勳，他介於象徵主義和超現實之間的個人風格其實已經浮現。如果說從媒材方面很難界定李子勳的創作屬性，那麼，在創作風格方面也很難加以歸類，他那種近乎遊樂園的大型多彩劇場裝置，表面上看起來有普普藝術的外觀，在內涵方面卻和普普藝術恰恰相違背。隱喻式的敘事性始終是他的作品中持續的主軸，各種媒材只是他用來編輯故事的工具。所以從早期的平面繪畫，到德國留學時期的大型裝置，到近期朝向數位多媒體的發展路線，都只是他視覺神話故事的表述材料和手法而已。所以，與其說現代主義的美學教育奠定了大多數 20 世紀當代藝術家抽象思維的養成基礎，那麼李子勳的源頭是屬於中世紀的手工精神。移居到德國，是李子勳藝術生涯最重要的轉捩點，他密集式的長時間苦力勞動以求手工精確的完美追求，正是德

國藝術從中世紀以降的悠久傳統，在德國，他找到了扎根的土壤，在那裡他獲得了認同與肯定。

　　德國杜塞道夫藝術學院求學期間，身處異鄉的孤獨靈魂，沒有社群或體制範例的約束，也沒有同儕相斥的無形壓力，反而允許他與自己的心靈對話，促成他自我的全然解放，可以專心一意投入他最愛的藝術創作；而一些來自故鄉的溫暖支援，可以使他在媒材和技術上極力追求完美，立足於早年受到的純熟訓練基礎上，全心投入在創作的忘我天地裡，以廢寢忘食來形容他對藝術的迷醉也絲毫都不為過。像李子勳這樣的藝術家，他很幸運地在他生命的成熟期，被暫時移植到德國的那片土地上，因為只有德意志那樣的民族性，嚴謹精確又克勤克儉，他們對中世紀刻苦耐勞的手工所打造的偉大傳統，仍有一定程度的懷舊與嚮往，甚至對於極度壓抑肉身的折磨下，所激發出的璀璨情緒光芒，也有一定水準的欣賞和理解；倘若李子勳當年是去美國留學，在美式速食主義和消費文化的環境裏，恐怕很難養成像李子勳這樣的苗子；杜塞道夫藝術學院提供了極為自由的學習環境，而學校工作室內的器械設備和技術人員的指導，也都直接、間接提供了李子勳完成作品時程的輔助需要，一件作品可以任他玩上一、二、三年以上，而教授不以交作業成績的理由，逼迫他按照既定的進度去完成作業，也讓李子勳可以為所欲為，從一些拾獲的廢料開始，漸漸發展成大規模的裝置藝術，這是後天際遇對他的影響。

　　1997 年的〈機械人〉系列是他在德國成熟的早期代表作之一，也是他開創日後大型機動裝置作品的雛形。1998 年的〈四種不同飛行物體的想像〉、〈國王和皇后的家庭〉和〈宮殿內的戰爭〉等平面作品，則是他在臺灣時期畫風一以貫之的精進。〈大魚〉採取了平面結合彩光、動力裝置的浮雕式複合媒材作品，是李子勳另一方向的里程碑，也是他日後創作大型裝置以外的主要表現型式；從 1998 至 1999 年費時一年餘完成的〈愛情殿堂〉是此一時期的巔峰之作，由一段戀情而激發的愛情場景，不僅僅是他對這段關係的詮釋、經營和演化的過程，也是他自己煞費苦心打造的一個祭祀虛擬的愛的儀式場域，絢爛、童趣、彩色聲光的繽紛外表下，掩藏了他的失落和孤寂。平日不喜歡與人交際的李子勳，作品就是他的伴侶，是有靈有肉的「擬人」，對他而言，是一種真實的存在，他在創作的進程中，和愛情殿堂中的角色互動是一種心理狀態的視覺化演出，因此形成舞臺劇場的效果，而觀眾也自然被吸引進入殿堂的場域內，探索作者心底的奧秘。

　　李子勳在他的創作自述中表示：「從事創作之前，曾經希望能學習建築。記得每次路經科隆大教堂，總是被歌德式建築宏偉向上伸展的氣勢所震撼，當近距離觀看時又為那充滿想像力細膩的浮紋雕飾所吸引著迷。我想這對後來創作偏好具體積質感的大型雕塑，和實踐『細節構成整體，兩者等同』的觀點形成，產生了重要的影響─建

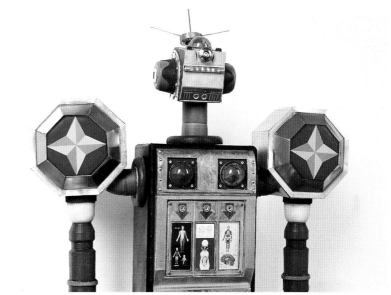

未完成的〈機器人 0 號〉製作於 1996 年德國萊比錫（Leipizig）　　Unfinished "Robot 0", made in Leipizig, Germany, 1996

築構成的具體堆積方式，以及架構內追求統一均衡的定律；之後我一直將此運用在所有的雕塑及繪畫平面作品營造的佈局中。」〈愛情殿堂〉正是李子勳創作理念的完整實現，他在 1999 年曾以此作品參加比利時哈塞特美術館所舉辦的國際展，又在 2001 年參加德國巴登美術館的展覽，獲得觀眾票選最受歡迎的作品。這年李子勳設計了動態聲光道具和佈景，在國立杜塞道夫藝術學院，和大提琴手凱瑟（Marcus Kaiser）聯合演出一場實驗劇〈製造愛情的過程〉，這是他克服羞怯的本性，首次在公眾面前進行的行為表演藝術（Action and Performance Art）。至此，李子勳終於完成了他達成總體藝術（Total Art）的願望，他的創作橫跨了繪畫、雕塑、裝置、建築結構設計、光（Light Art）和動能藝術（Kinetic Art），以及行為表演藝術等領域，這才是他所認可的發表型式，只完成其中的任何一部分，對他而言，都是不完整的。

　　1999 年推出〈愛情殿堂〉之後，李子勳獲得相當的好評與鼓舞，他隨即展開另一件更大件的巨型作品，這一次他耗時長達三年，在 2002 年完成近四米高的重要代表作〈迷宮劇場〉，及時趕上參加臺北市立美術館的「臺北雙年展」，彷若是遊樂場的不斷旋轉舞臺，令所有觀者印象深刻，受到各方面的好評。在創作〈迷宮劇場〉的三年之間，他少數幾件像〈理智和感知的界限〉、〈奇妙秩序〉、〈無限長的睡眠〉等小型作品，算是他在進行重大工程過程裏的休憩與娛興；然而這些作品，立刻攫獲觀者的好奇心，誘使他從 2003 年開始製作了〈機率遊戲〉、〈水的循環〉、〈私密的物件〉、〈展開的物體結構〉、〈趣味的圖像結構〉、〈天使的秘密〉、〈魔鬼的臉〉…等中、小

型的複合媒材作品，擬人化的造型漸漸減少。在他最新的大型裝置〈玻璃珠遊戲的秘密〉中，人形完全消失，機械化的構成彼此帶動旋轉，撥動地面上二千多顆的透明玻璃珠子，從他早期偏向敘事性的路線，往語意更加模糊的隱喻方向發展。〈玻璃珠遊戲的秘密〉參加筆者去年在臺北當代藝術館策劃的「虛擬的愛—當代新異術」國際展，同時，也在臺北誠品畫廊舉辦個展，出人意表地展出不少平面繪畫，特別是一張大幅的〈迷宮劇場—建築設計方案設計〉的大畫，清晰地看明白他意在建築的用心，他的紙上城堡，如果有朝一日獲得實現，應該是他的終極目標。年輕藝評家李維菁在臺灣民生報有一段對李子勳之創作十分精闢的見解，她說：「除了他特殊的內容掌握，更在於他對物質形式的準確度相當高這一點。他擅長將極夢幻的主題情感用極物理現實來操作展現，兩者之間的對比才構成了作品的獨特美學。」

2004 年李子勳所作的〈一個婀娜多姿的造型〉和〈一千次的跳躍實驗〉、〈一對〉、〈循環運動〉等以白色為底的繪畫系列，將主題置於左右對稱的畫面上，如此更加突顯了中心主題的重要性，李子勳自己表示是一種將主題集中「聖化」的手法；其他複合媒體的〈墨綠色背景的未知空間〉、〈飛行器〉、〈十字精神〉、〈為思考所存在的構圖〉等「類浮雕」作品，則隱約指向一條更新的創作途徑，為他將來結合數位化媒材的動畫鋪墊了基礎。從李子勳早期的機器人開始，由機械帶動的生命化的光與動能，擬人化的行為模式，經歷了遊樂場式的戲劇化舞臺階段，他在新的作品中，逐漸不再強調擬人化的生命演出，也不再躲在機器人武士的軀殼裏，扮演成影舞者默劇的演員，這回他躍出了自己的作品，所營造的遊戲場，是觀眾和他作品之間直接的互動，退居幕後的李子勳，反而成了一旁看戲的人。常在他作品中出現的武士、公主、嬰兒、人腦的切面、城堡、馬匹、心型物、機器人、水、魚，對他本人必然具有特別的意義，但是每一位觀者也都能觸動出他們自己的想像。所以，原本私密的個人圖像符號，也能夠轉變為觀眾可以自訂定義的記憶符碼，在心理遊戲過程裏，各自保有了每一個人獨有的私密性。

到目前為止，李子勳是臺灣極少見的「世外型」的藝術家，一般人很難斷定他的歸屬（identity），他其實可以在任何國家或地區安身立命。也正因為如此，他的創作美學是具備無國界的宇宙性的特質，完全無需從東西文化對立的角度切入。他的人和他的藝術似乎活在沒有國界，沒有邊際的，沒有時域（time zone）的環境裏。他在生活方面，基本上和一切俗世的考量脫勾，筆者曾在旅歐途中特地造訪李子勳在杜塞道夫的工作室，驚訝於他生活的簡樸和創作所投入的資金和心力，簡直是太強烈的落差和對比。他用苦行僧的毅力和自勵，可以與世隔絕地連續幾天僅以麵包和白開水裹腹，卻對龐大作品巨細靡遺的每一零件和組構，都竭力追求完美，而且必須親力親為悉心打造，半點不肯馬虎，一點都不放過；這種看來和藝術無關的生活瑣碎事務，卻

和他的創作心態有十分密切的關係。李子勳對使用媒材素質的高度敏感，使他的精神很容易專注於物質本身條件的營造，完全不受個人情緒或外在環境的影響。早年受到德國漢諾威達達主義藝術家史維塔斯（Kurt Schwitters, 1887~1948）所創作的〈梅茲堡〉（Merzbau）的啟發，是以細節的組合來呈現整體的視覺效果，是他自己所言的「細節構成整體，兩者等同」的理念，也就是他所堅信的：「人的本質中存在著一個完美的原型，藝術進行不斷改變，最終就是為了達到這個近似自然的本質，一個持久的整體均衡狀態」，所以，無論在他的人生中或創作生涯裏，這種「細節構成整體，兩者等同」對李子勳而言，都是同樣的道理。

理論上，很難光是以藝術家的身份去表述李子勳，也很難以他的作品風格去歸類他屬於那一種時代性的主義或潮流。他的時間，互古彌新，他的創作，從他個人生命的演出，到營建演出生命角色的舞臺，到近年來逐漸向數位化的遊戲領域靠攏。他的世界裡，充滿了虛擬的人物和角色，對他而言，那些如玩偶般的人形，其實，都是他生活中真正和他產生互動的人物，他賦予他們高度的象徵性意義，使他們在想像中能夠有血有肉，這點其實和電玩世界是非常接近的。李子勳在他的作品中，實現了扮演默劇演員、建築師、舞臺道具設計師的角色，下一步，他也可能成為遊戲腳本和人物造型的原創者，為廣大無邊際的人工智慧添加一些人性矛盾和人心浪漫的豐富故事。李子勳象徵著新世紀新一代的藝術家的典型能夠悠游在各種專業領域之間，他們的藝術創作是從自己的生活經驗中全方位擷取，會說故事，是 21 世紀最被需求的人才，而李子勳則剛好是天生的視覺版說書者。曾被稱為藝術界的唐吉訶德，其實李子勳更像是在時光隧道中迷途的頑童，他興致勃勃四處探索，這份玩興使他徜徉在無限可能的過程中，永遠不會長大，也不會變老。

The Aesthetic Palace Linked by Tzu-hsun Lee's Momentary Memories

Victoria Lu Curator

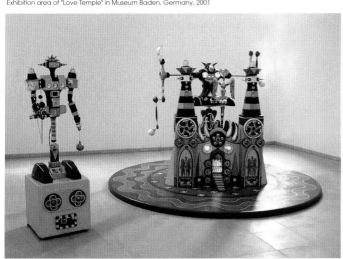

Exhibition area of "Love Temple" in Museum Baden, Germany, 2001

Born in 1973 in Taipei, Tzu-hsun Lee showed an early interest in art and manifested his exceptional creative talent under the loving care of his family. When he reached high school age, he chose to enter the famous art school, the Fu-Hsin Trade and Arts School in Taipei, where he received the strictest basic training. In addition, he took various courses outside the school. After graduation, he joined the army just like other young boys of his age. Later, fate brought him to Germany, where he pursued further studies. This experience has had a decisive influence on his artistic career. After graduating from the Kunstakademie Dusseldorf, Lee has been living and working as a professional artist in Cologne, a centre of contemporary art in Germany. He is now engaged in the creation of large-scale works and interdisciplinary and multimedia research.

It is difficult to classify Lee's art by medium. Because he always wanted to be an architect, his works naturally employ space as the stage of his representation, and large installations have become his favorite form of expression. The virtual art world in his works is closely related to his dramatic real life. The endless connections and echoes between the two are just like a series of pantomimes in which only the actor is the focus. It is a world without a noisy stage or special lighting effects. Only the closest audience can feel his deep sorrow or great joy erupted from the silence. The stark contrast and tension generated from it not only touches his every sensitive nerve, but also reflects his taciturn and low-key personality. The intense emotions hidden under his pale skin tempt the spectators to further approach his work, inevitably producing psychological interaction. Since Lee voluntarily plays the role of a mime, no one can hear the fierce cry from the bottom of his heart. But as you stand before his work, you can always sense his deepest feelings via his witty and subtle interpretation. The struggles and entanglements of life, death, love and hatred are concealed under the bright colors and formal aesthetics. He represents the dream scene at the back of his mind by patiently building up the details of each part by hand to form a magnificent spatial installation, turning his personal belief into a spiritual palace that can be shared by everyone. Such a laborious process of creation is inconceivable to those who produce art in an assembly-line manner.

Tzu-hsun Lee's unique individual style between Symbolism and Surrealism

was shaped before he went abroad. If his work cannot simply be classified by medium, his creative style also eludes definition. His large colorful stage installations are just like an amusement park. They have the appearance of Pop Art, but their meaning is totally different. The various media are just a tool he uses to compile the story, since the eternal theme of his works is the metaphorical narrative. From the early two-dimensional paintings to the large installations when he studied in Germany, up to the recent digital and multimedia works, they constitute only the materials and the techniques for creating his visual fairy tales. If the main abstract tendencies of 20th-Century artists were derived from modernist aesthetics, then Lee's unique style is more akin to the medieval handicraft spirit. The turning point of Lee's artistic career is his move to Germany. He spent a long time working intensively to perfect his handicraft. This corresponds to the age-old tradition of German art from the Middle Ages. In Germany, he found the soil for his art's growth and it is there that he is also recognized and held in great esteem.

During the time when he studied in Germany, a lonely soul in another country, he was no longer bound by the rules and conventions of the community or the system, and was free from the invisible pressure of his peers. This enabled him to enter into a dialogue with his soul, making it possible for him to completely liberate himself and immerse himself in artistic creation. With support coming from his hometown, Lee was able to strive for perfection in terms of media and technique. Building on the firm foundation of his early training, he devoted himself wholeheartedly to art. As an artist, Tzu-hsun Lee was lucky to be transplanted to Germany in the prime of his life. That is because only the serious and frugal German nation still feels some nostalgia for the great tradition of meticulous handicraft in the Middle Ages. Furthermore, they have an affinity for beauty produced under extreme physical exertion. If Tzu-hsun Lee had gone to the United States, it might have been difficult for him to develop this way under the fast food and consumer culture. The Kunstakademie Dusseldorf provided him with an extremely free studying environment. Apart from that, the equipment in its studios and the guidance of its technicians offered direct or indirect assistance for the completion of Lee's works that did take two or three years. Moreover, the professors never tried to make Lee finish his assignments in the scheduled amount of

time, thus allowing him to do whatever he wanted. Beginning with the collection of junk, his works gradually developed into large-scale installation art. This was due to the influence of later experiences in his life.

The *Robot* series in 1997 was one of his early representative works in the mature period in Germany and the prototype of his later large motor-driven installations. The two-dimensional works *Four Different Imaginations of A Flying Object*, *Household of the King and Queen* and *War in a Palace* in 1998 carried on and improved upon his painting style in Taiwan. *Big Fish*, the multimedia relief work combining color light and motor devices, is a milestone in another direction and the major form of expression of his later works apart from the large installations. Love Temple, which took more than one year to make from 1998 to 1999, is another masterpiece from this period. This work spawned by a love affair not only represents his interpretation of that relationship and its transformation, but is also a place of ritual and an altar to virtual love built by him. His sense of loss and loneliness are concealed under the brilliant, childlike and colorful surface. For Tzu-hsun Lee, the unsociable artist, his works are his companions, like real people made of flesh and blood. In the course of creation, his interaction with the roles in the Love Temple resulted in a visualization of his psychological state, thus producing the theatrical effects that draw viewers into the drama to explore the mystery at the bottom of the author's heart.

Tzu-hsun Lee has described in his artist's statement: "Before becoming an artist, I had dreamed of studying architecture. I still remember that whenever I passed by the Cologne Cathedral, the magnificent rising style of gothic architecture always impressed me. Seeing it from a nearer distance, I was attracted by the imaginative and fine decoration and relief. In my view, this was influential in my later preference for large sculptures with rich texture and the shaping of the idea that 'the details constitute the whole and they are equal'. The accumulative principle of architecture and the search for unity and balance in the structure are ideas I have henceforth applied to the composition of all my sculptures and paintings." *Love Temple* is the complete expression of Lee's creative ideas. In 1999, this work was shown in an international exhibition at the Hasselt Art Museum in Belgium and won the Audience Award in an exhibition held by Museum Baden, Germany in 2001. In the same year, Tzu-

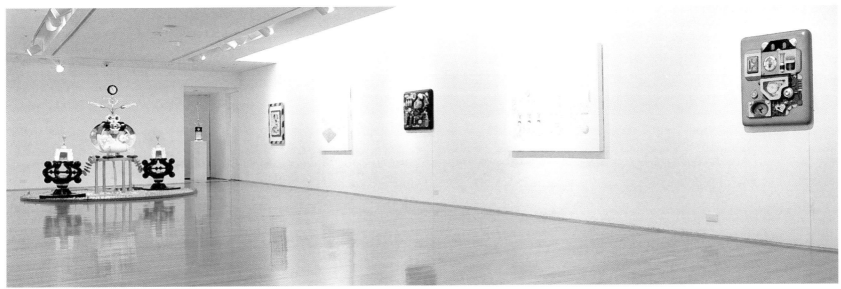

Solo Exhibition "Mystery of the Glass Bead Game" at Eslite Gallery, Taipei

hsun Lee designed a movable stage property and stage setting with music and lights, and performed the experimental theatre *The Process of Manufacturing Love* at the Staatliche Kunstakademie Dusseldorf with cellist Marcus Kaiser. It was the first time he had overcome his shy nature to carry out action and performance art in front of the public. Lee finally achieved his dream of Total Art. His work spans the fields of painting, sculpture, installation, architecture design, light art, kinetic art and action and performance art. This is the mode of presentation he favors--finishing only one part of it is to him incomplete.

After *Love Temple* in 1999, Tzu-hsun Lee received a lot of good reviews and encouragement. He embarked on another even larger project at once, which took him all of three years. In 2002, he completed the almost 4 metre-high important work *Maze Theatre*, and participated in the "Taipei Biennial" organized by the Taipei Fine Arts Museum. The work resembling a roundabout in an amusement park impressed audiences a lot and won praises from all sides. During the three years of the production of *Maze Theatre*, he made a few small works like *The Boundary between Sense* and *Sensibility, Fabulous Order* and *Endless Sleep* for his own amusement during breaks from his great project. These works at once captured people's attention, prompting him to

make small and medium-sized multimedia works such as *Probability Game, Water Cycle, Personal Belongings, Unfolded Object Structure, An Interesting Pictorial Structure, Angel's Secret* and *Devil's Face* etc. from 2003, in which the anthropomorphic forms gradually diminished. In his latest large installation *Mystery of the Glass Bead Game*, anthropomorphic forms have completely disappeared. Instead, the mechanical constructions cause one another to revolve, churning some two thousand glass beads on the floor. The narrative tendency in his early works is now substituted by even more obscure metaphor. *Mystery of the Glass Bead Game* was shown in the international exhibition "Fiction · Love - Ultra New Vision in Contemporary Art" in the Museum of Contemporary Art, Taipei curated by me last year. Meanwhile, he held his solo exhibition at the Eslite Gallery in Taipei. Surprisingly, he showed some two-dimensional paintings, especially a large work *Maze Theater - An Architectural Design* that clearly displays his interest in architecture. His castles on paper may be his ultimate goal to realize in the future. The young critic Wei-Ching Lee wrote insightfully on Tzu-hsun Lee's art in Taiwan's Min Sheng Pao: "He is remarkable not only for his grasp of content, but also for the high precision of his physical forms. He is adept at treating extremely dreamy subjects through the manipulation of an extremely physical reality. The contrast

between the two constitutes the unique aesthetic of his work."

In 2004, Tzu-hsun Lee's painting series on a white ground, including *A Graceful and Charming Figure, One Thousand Diving Experiments, A Couple* and *Cyclic Motion,* places the motifs on a symmetrical composition, thus stressing the importance of the theme. Lee himself describes it as a way of "apotheosizing" the subject. Other "relief-like" mixed media pieces like *Unknown Space on a Dark Green Background, Flying Object, The Spirit of the Cross* and *Composition that Exists for Thinking vaguely* suggest a new creative approach and pave the way for his animation works combining digital media. After his early robots, with light and kinetic energy driven by machines imitating human behaviour, he went through a period of building an amusement park-like dramatic stage. In his new works, he no longer emphasizes anthropomorphic forms nor hides inside the body of a robotic knight, disguising himself as a pantomime actor. Instead, he detaches himself from his work. The pleasure ground he now presents consists of direct interaction between the audience and his works. Retired to the backstage, Tzu-hsun Lee is now a spectator. While the knights, princesses, infants, sections of the human brain, castles, horses, heart-shaped objects, robots, water and fish that frequently appear in his works certainly have special significance for him, each viewer can also use his own imagination. Therefore, private iconographic symbols can also be transformed into memory codes that audiences can define by themselves. In such a psychological game, everyone retains his own unique privacy.

Tzu-hsun Lee belongs to a breed of "unworldly" artists rarely seen in Taiwan. It is hard to define his identity, for he is able to settle down anywhere in the world. That is why his aesthetics has a universal character and has no frontiers. In his work, there is no question of a conflict between eastern and western culture. He and his art seem to exist in a place without national boundaries, borders and time zone. His way of life is almost devoid of earthly considerations. During a trip to Europe, I paid a visit to Lee's studio in Dusseldorf and was surprised at the enormous difference between his simple life and the great amount of capital and efforts he devotes to his work. With ascetic fortitude and self-drive, he can isolate himself from the outside world for several consecutive days, living on bread and water only. Yet, he strives for perfection in every small component and structure of his huge work, does everything himself with utmost care, leaving nothing to chance. At first sight, such trifles in his daily life have nothing to do with his art, but in fact, they are closely related to his mental state while creating. Because of his high sensitivity to materials, he can easily concentrate on working with the materials, undisturbed by any moods and oblivious to the outside world. Early in his career, he was inspired by Kurt Schwitters's (a German Dadaist born in Hanover) "Merzbau", which uses collages of details to achieve the overall visual effect. This is consistent with his idea that "the details constitute the whole" and his belief that "there is an ideal prototype of the essence of mankind. Through constant transformations, art seeks to attain this quality that is near to nature, a state of lasting equilibrium". Thus, the principle "the details constitute the whole" has the same significance in Tzu-hsun Lee's life and artistic career.

Theoretically, it is hard to depict Tzu-hsun Lee merely as an artist, or put him under any art movement or trend according to his style. His time is ancient yet new. After telling the stories of his own life and building the stage of life, he has gradually turned to digital games in recent years. His world is full of fictitious people and roles. To him, these doll-like human shapes are in fact characters interacting with him in real life. They are endowed with highly symbolic significance, which makes them flesh and blood in the imagination. This is quite close to video games. In his works, Lee has played the role of a pantomime actor, an architect and a designer of stage props. Next, he might become a creator of game script and characters, contributing stories about human conflicts and romance to artificial intelligence. Tzu-hsun Lee represents the type of a new generation of artists in the new century who can move freely between different fields. They derive their work from all aspects of their daily life. They are good at telling stories, which make them the most sought-after talent in the 21st century. Tzu-hsun Lee is a natural-born visual storyteller. Once regarded as the Don Quixote in the art field, Tzu-hsun Lee is more like an urchin lost in the time tunnel. He wanders about exploring excitedly, which enables him to remain young and innocent, playing with infinite possibilities.

PLATES

機械人 | **Robot I** 1996

綜合媒材：色鉛筆、壓克力顏料、紙、木材、塑膠、金屬、燈、馬達、
機械裝置、喇叭

Mixed media: color pencil, acrylic paint, paper, wood, plastic, metal,
lamp, motor, mechanical parts, speaker

12.5 × 23.5 × 100 cm

私人收藏・台北　Private Collection, Taipei

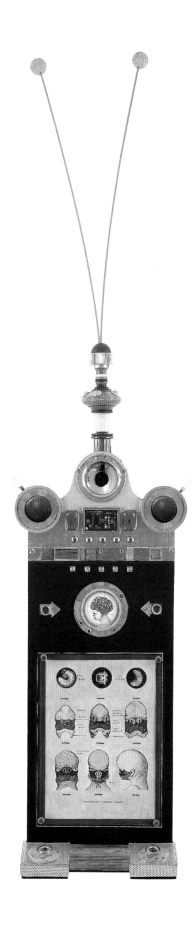

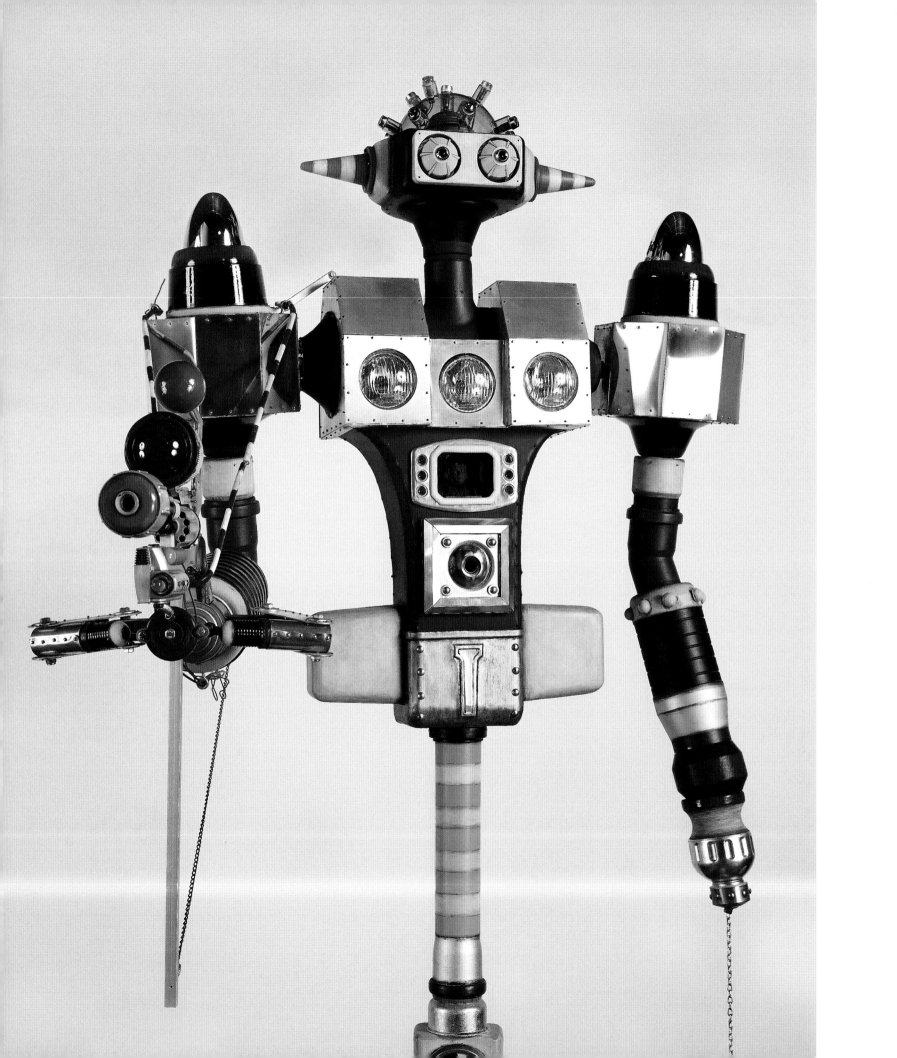

機械人 II　**Robot II**　1997
綜合媒材：壓克力顏料、噴漆、木材、塑膠、金屬、燈、馬達、
機械裝置、搖控器
Mixed media : acrylic paint, spray paint, wood, plastic, metal,
lamp, motor, mechanical parts, remote control
105 × 105 × 200 cm
機械人 II一局部　**Robot II - partial**（L）

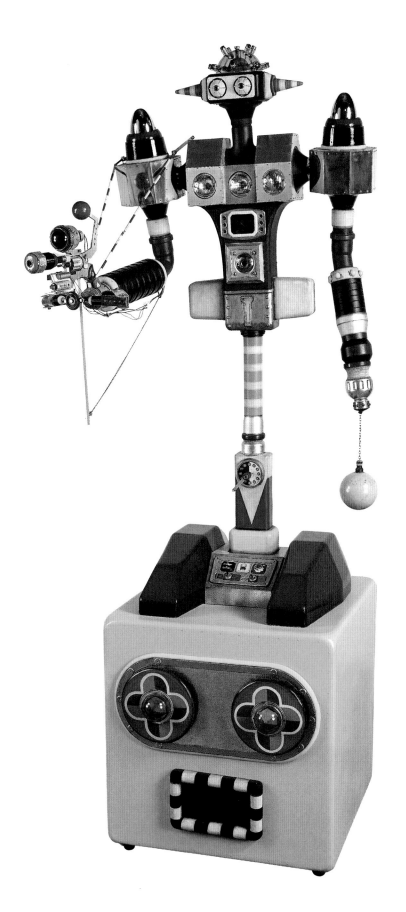

Four Different Imaginations of A Flying Object 1998

壓克力顏料、木板

Acrylic paint, wood panel

31 × 43 × 0.3 cm

國巨基金會收藏・台北 Collection of YAGEO Foundation, Taipei

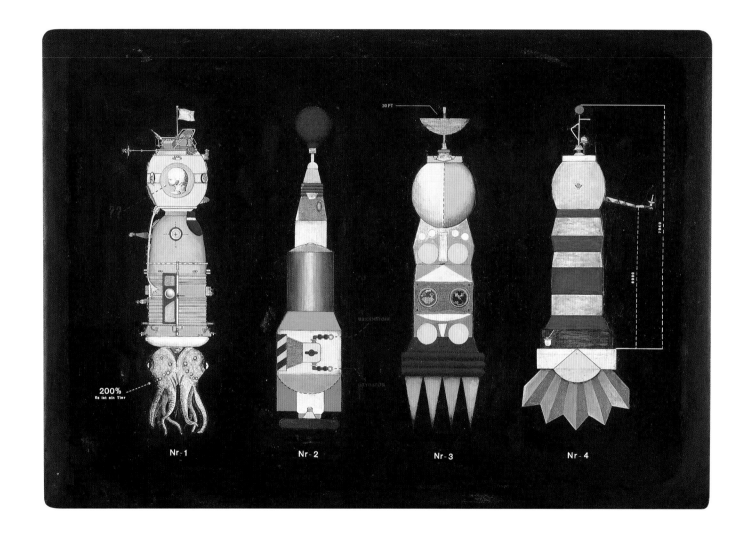

國王和皇后的家庭 **Household of the King and Queen** 1998
壓克力顏料、木板
Acrylic paint, wood panel
42 × 24.5 × 0.4 cm
國巨基金會收藏・台北 Collection of YAGEO Foundation, Taipei

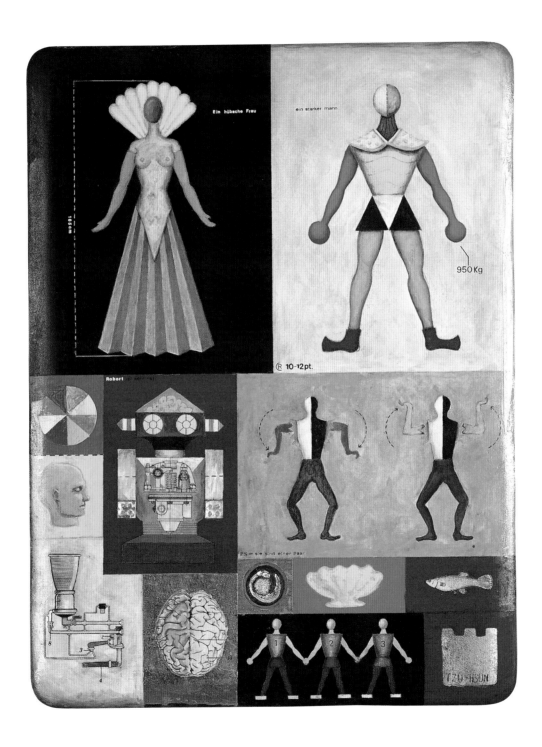

大魚　**Big Fish**　1998

綜合媒材：壓克力顏料、噴漆、木材、塑膠、金屬、燈、馬達、機械裝置

Mixed Media : acrylic paint, spray paint, wood, plastic, metal, lamp, motor, mechanical Parts

175 × 175 × 16 cm（釣竿至作品外延伸 145 cm　Fishing rod extends 145cm）

國巨基金會收藏・台北　Collection of YAGEO Foundation, Taipei

大魚－草圖素描　**Draft sketch of the Big Fish**　1997

鉛筆、紙

Pencil, paper

10 × 10 cm（每張・each piece）

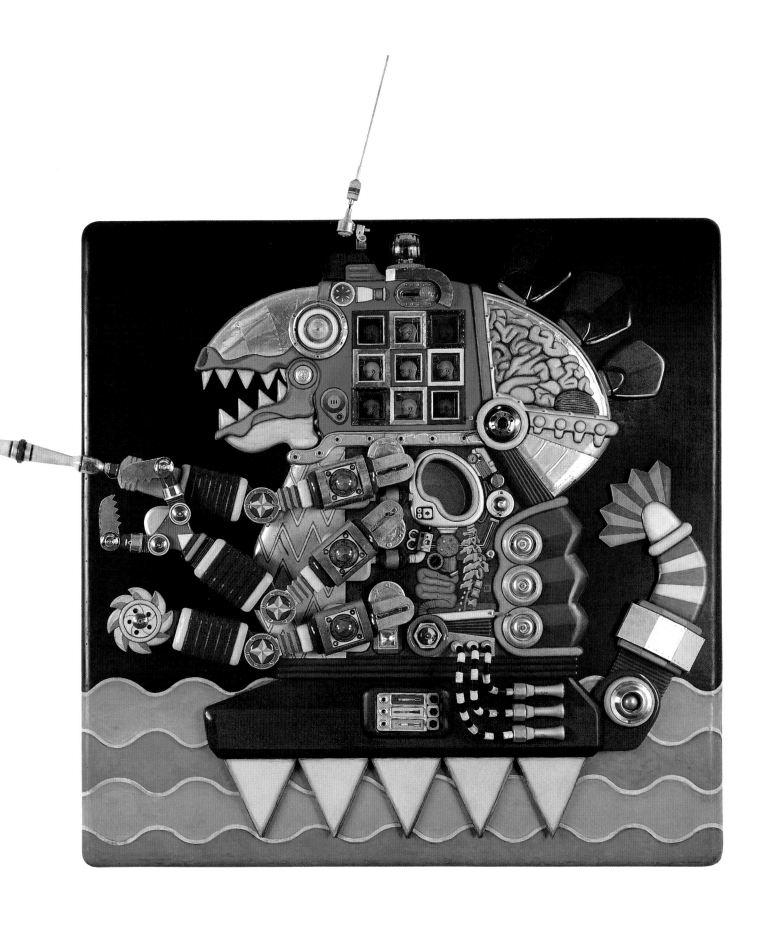

大魚—嘴部張合　**Big Fish - mouth in closed position**
大魚—局部　**Big Fish - detail（R）**

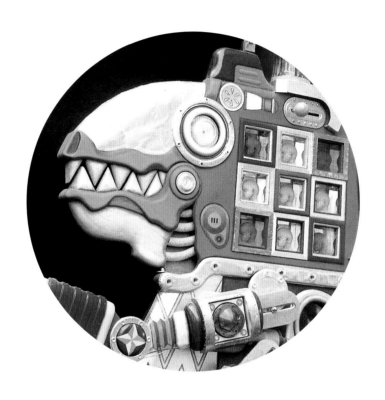

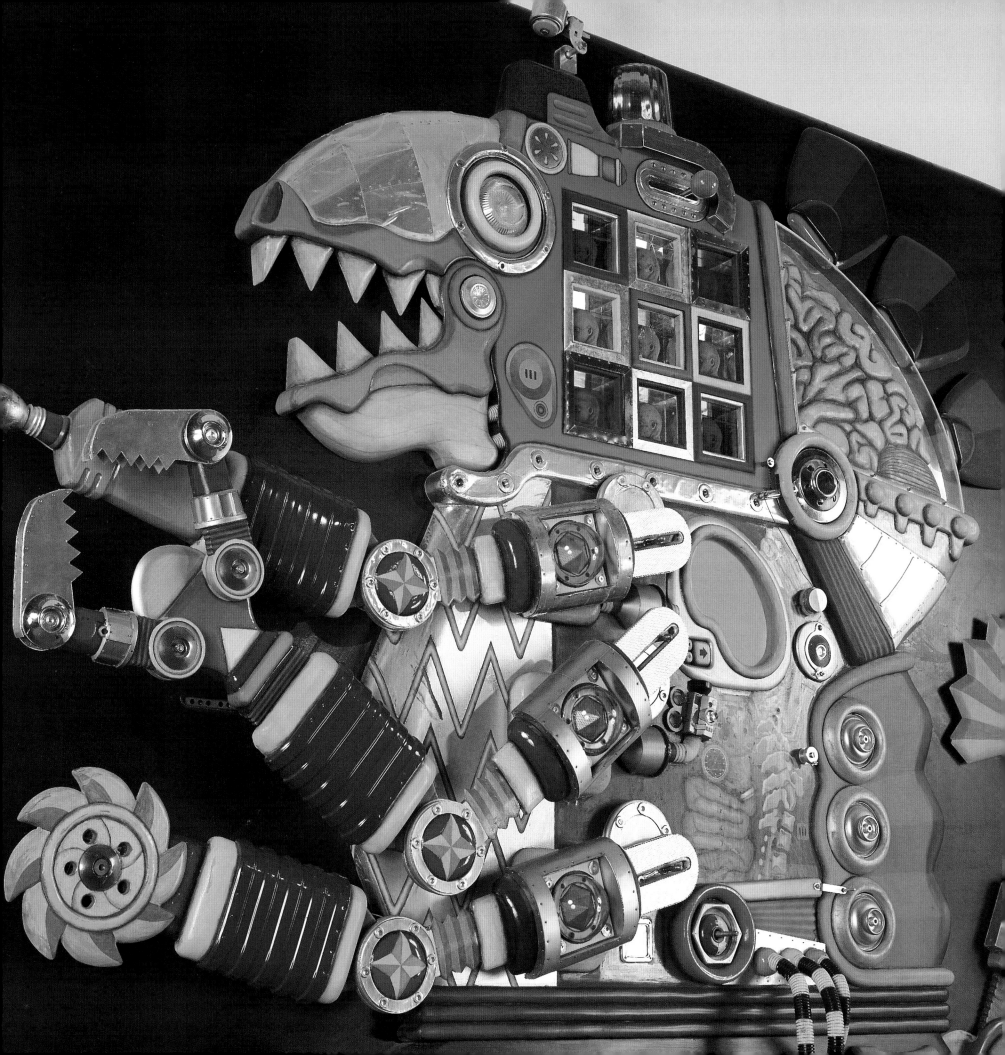

宮殿內的戰爭　**War in a Palace**　1998

壓克力顏料、木板

Acrylic paint, wood panel

49 × 62.5 × 0.4 cm

誠品股份有限公司收藏・台北　Collection of The Eslite Corporation, Taipei

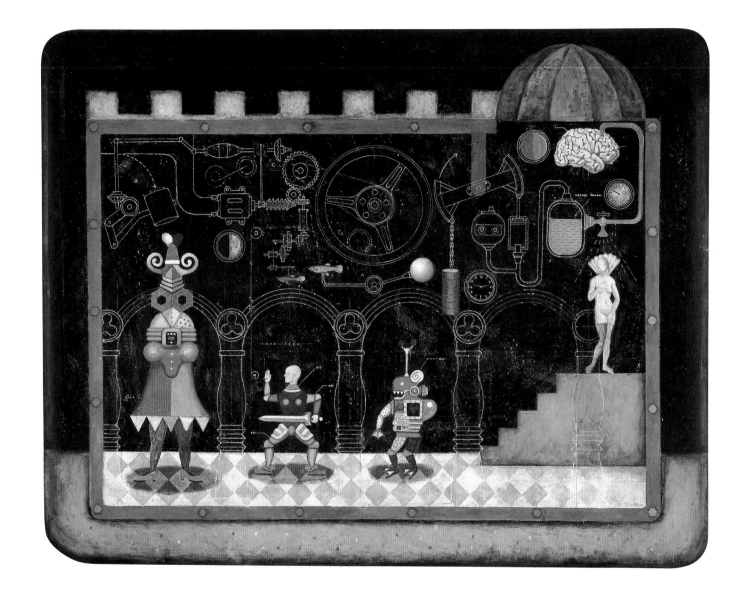

愛情製造 **Manufacturing Love** 2000

鉛筆、壓克力顏料、紙

Pencil, acrylic paint, paper

42 × 29.5 × 1 cm

私人收藏・台北

Private Collection, Taipei

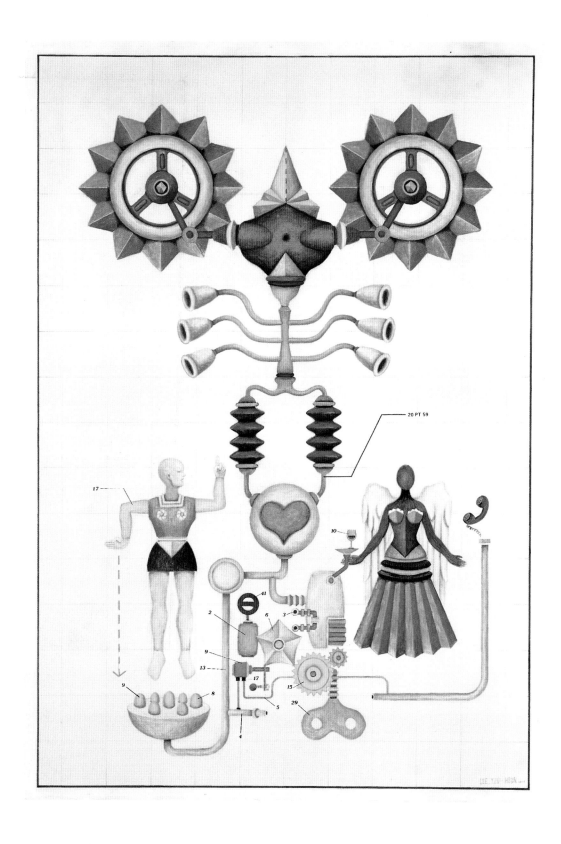

愛情殿堂—放置於黑暗空間　**Love Temple - shining in the dark**
愛情殿堂　**Love Temple**　1999（R）
綜合媒材：壓克力顏料、噴漆、木材、塑膠、金屬、燈、馬達、機械裝置、金魚
Mixed Media: acrylic paint, spray paint, wood, plastic, metal, lamp, motor,
mechanical parts, goldfish
ø :360 / H :185 cm

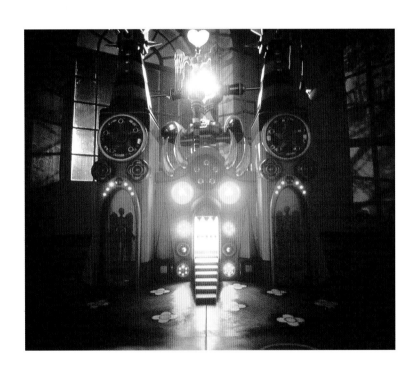

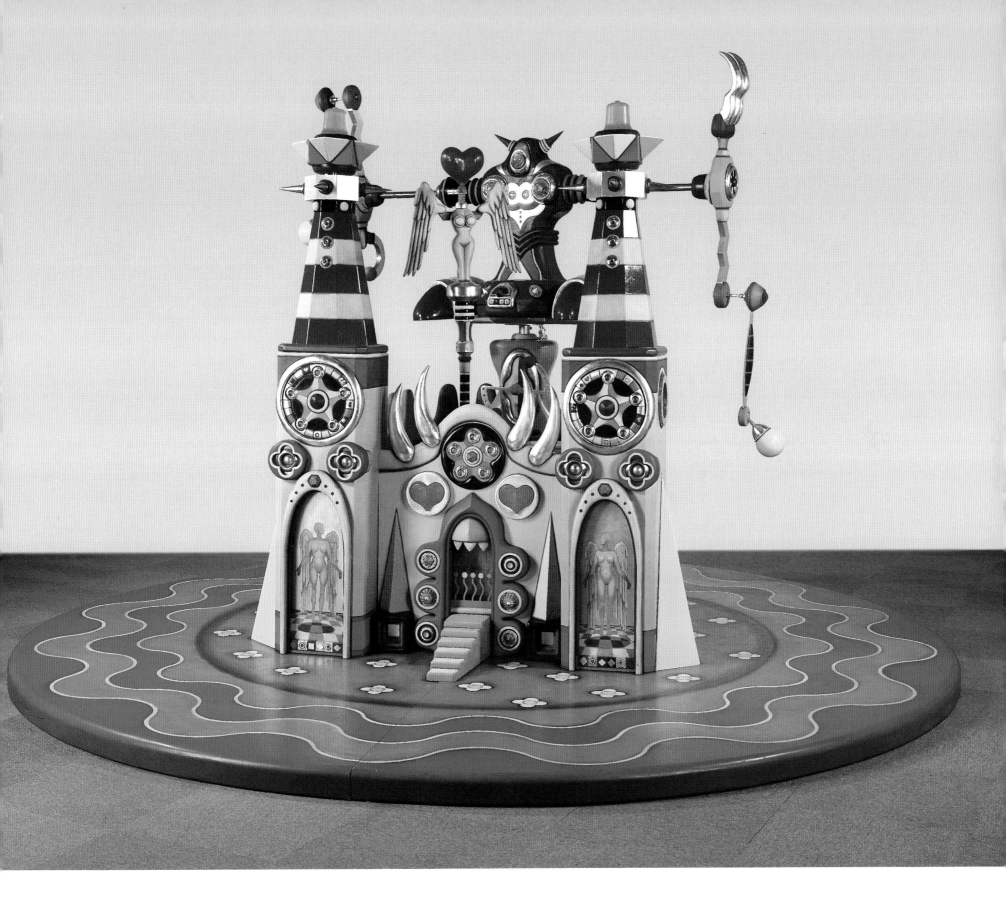

愛情殿堂－口中放置的金魚缸　Love Temple - Fish tank at the entrance
愛情殿堂－正上方俯視　Love Temple - seen from above

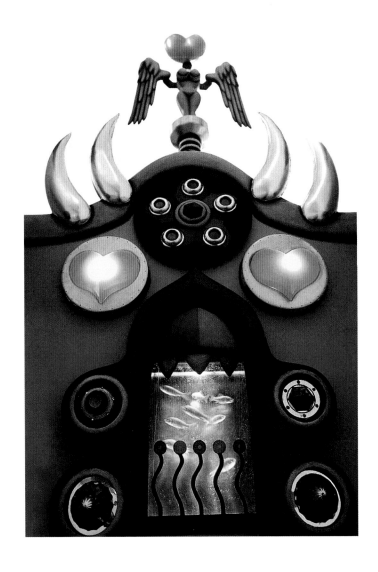

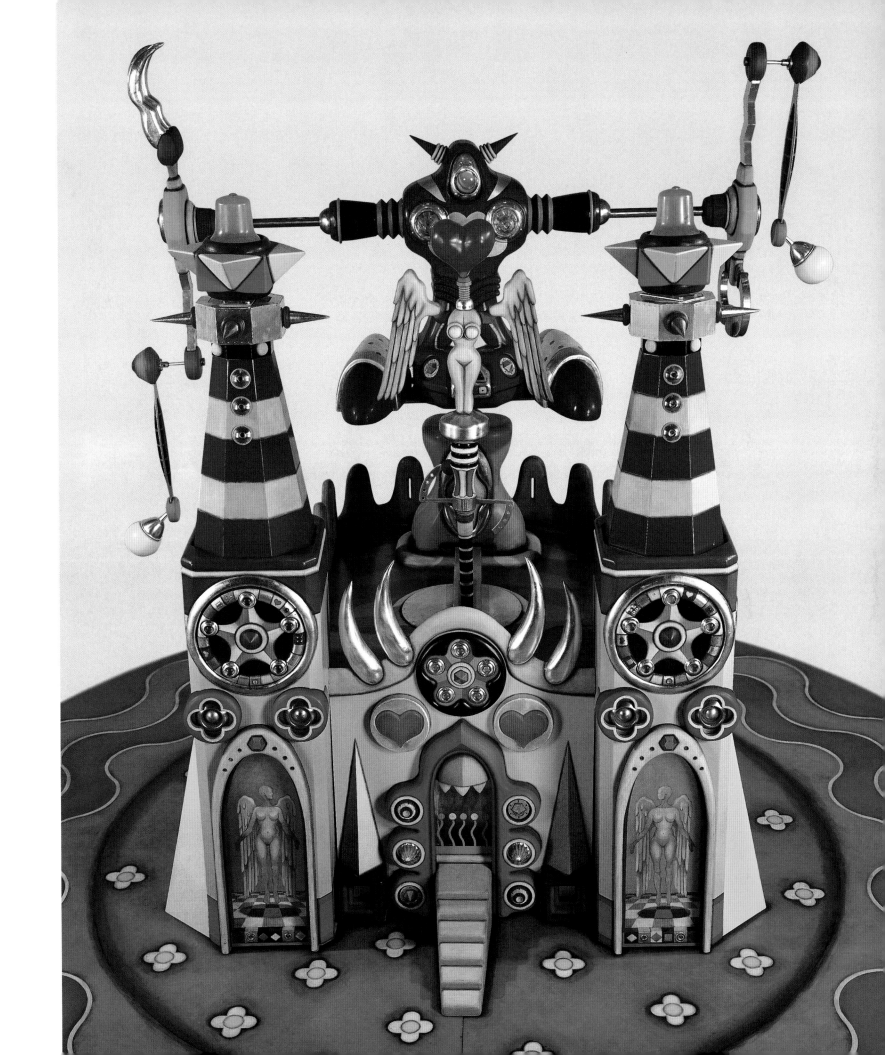

愛情殿堂—機械人後側
Love Temple - rear side view of a robot
愛情殿堂—愛情的命運轉盤
Love Temple - the fortune wheel of love（L）

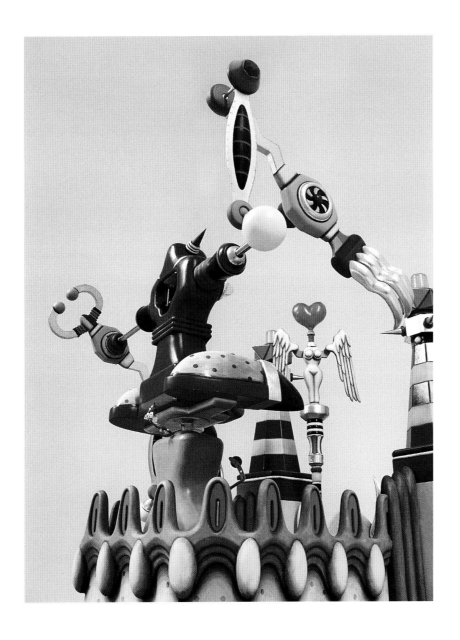

27

愛情殿堂—正上方俯視　**Love Temple - seen from above**
愛情殿堂草圖素描　**Draft sketch of the Love Temple**　1999（R）
鉛筆、紙
Pencil, paper
42 × 29.7 cm

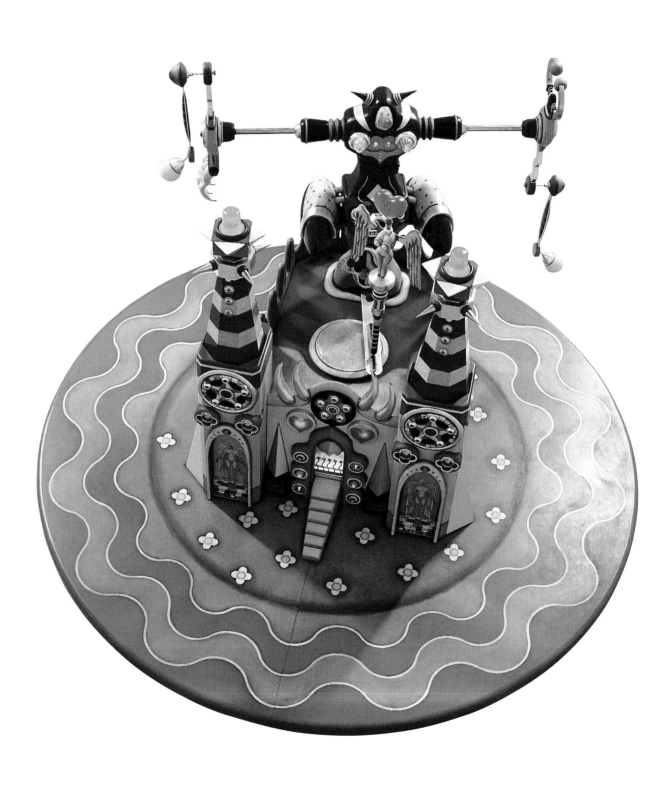

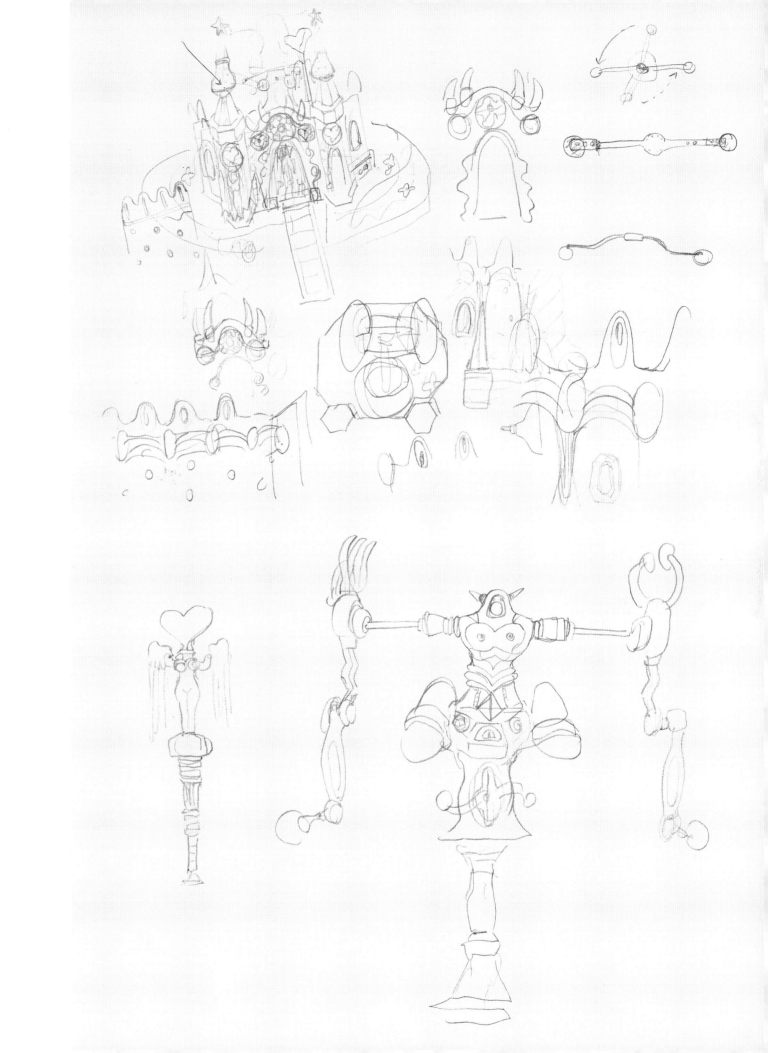

機械人體道具　設計素描 II　**Sketch design II of robots**
鉛筆、紙　Pencil, paper
29.7 × 46 cm
機械人體道具　設計素描 I　**Sketch design I of robots**（L）
鉛筆、紙　Pencil, paper
42 × 29.7 cm

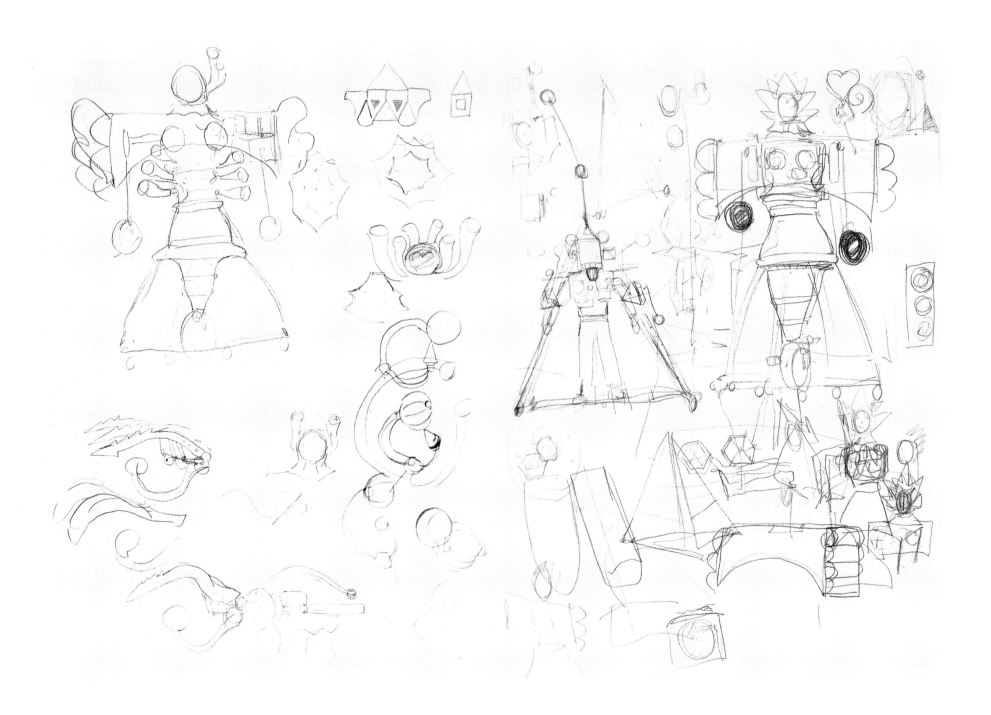

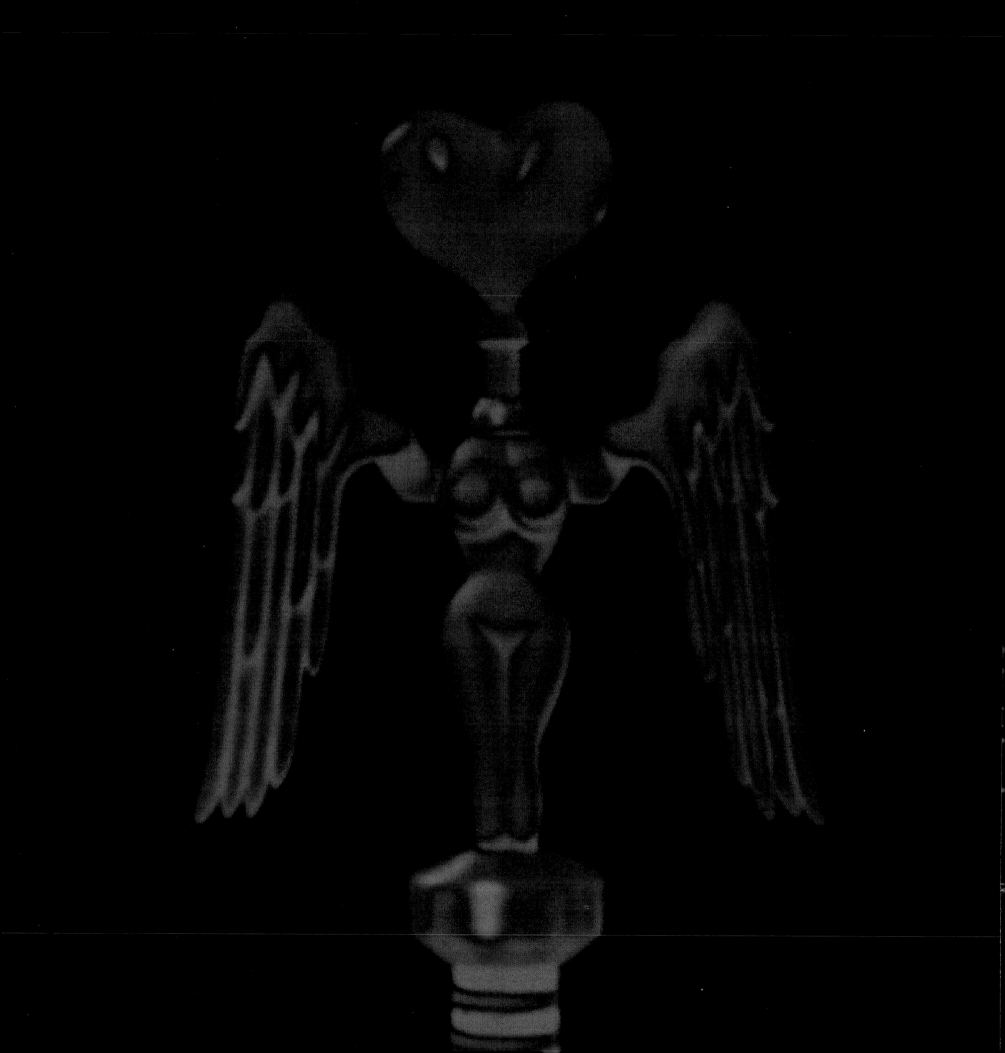

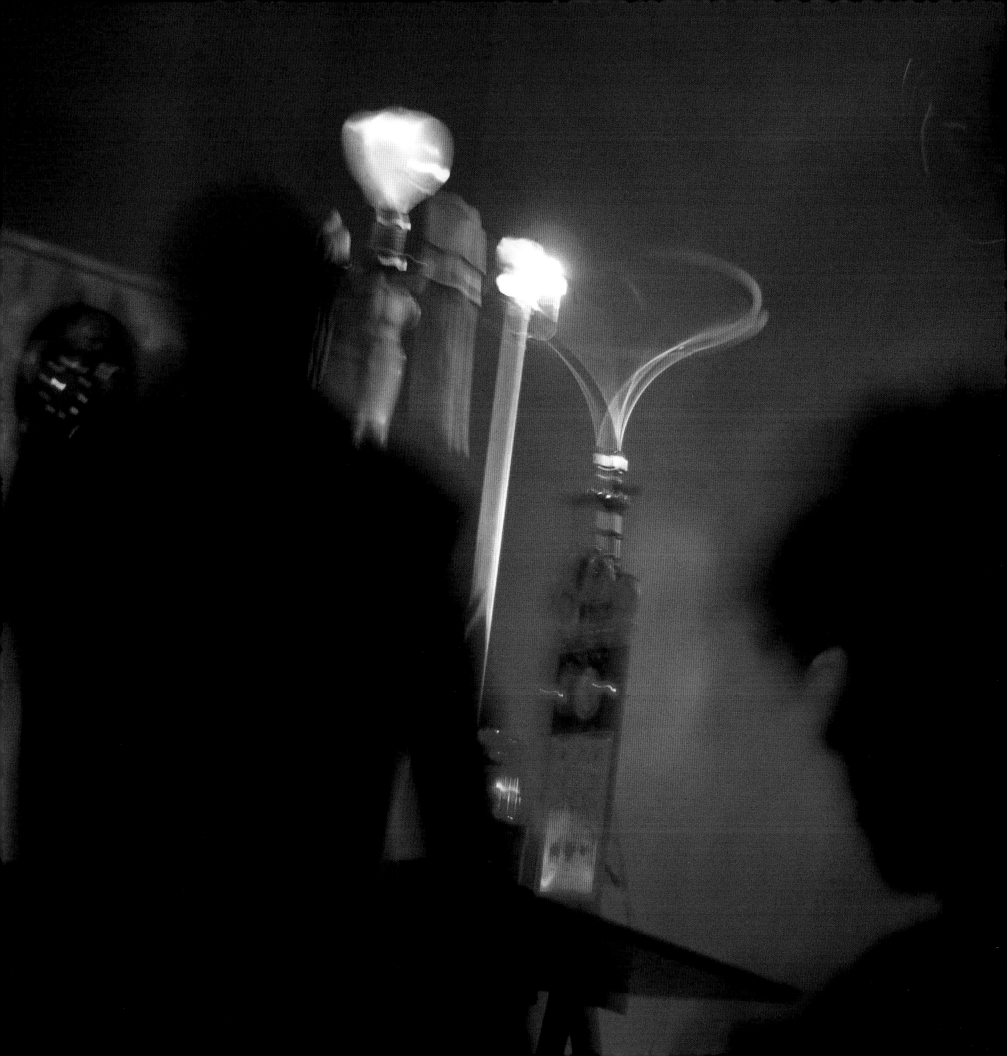

在某處虛構的實驗室內，正發生了一連串相關無意義的行為。在製造愛情的荒謬過程之中，一場儀式象徵的

程序和舞蹈，結合了光、聲音、動態裝置、身體，共同架構了一個非現實的想像空間。

一切開始於低頭的沈思許久，移動身體凝視著牆面的問號，企圖索求真理的答案，撕紙有如情緒般的起伏，

當地上落滿了無盡構成真理荒謬的數字後；一顆粉紅意象的心呈現在前，親手把它撕成無數無盡的碎片。

拿起一把利刀切碎了洋蔥和蘿蔔，將它們和已破碎心的「殘留」，混合於高舉手中那高傲剔透的水晶杯之內；

當細長的金屬湯匙，清聲觸碰水晶杯身體內部的同時，某種本質在我內心深處起了微妙的變化。

集中所有的精神和意志，心中冥想讚美著「她」。當她纖細如滴水的重量，輕輕穿透我身體的剎那；將杯中精

神和意志的殘餘，倒入女侍帶來那只無盡無底的平鍋，我當從那之中取出一顆真實的心。

在那心和軀體結合之時刻，現實有如鍊金術般幻化為一片紅光，我開始 ——

為了　她的身軀注入生命而舞蹈

為了　她冰冷的心復活而舞蹈

為了　她那顆如玻璃般半透明的心帶來光而舞蹈

直至她那柔軟的心中央，透出淡藍色溫暖的光暈，身軀緩緩地隨著我的舞步旋轉，大提琴琴音急促輕快、低

沈的迴旋於這充滿光地時間中。此刻，我將與眾不同地擁有她 ——直至一切結束。

In a fictitious laboratory, a series of related but meaningless acts is taking place. During the absurd process of manufacturing love, a ritual and symbolic process and dance integrating light, sound, dynamic installations and the body jointly create an unrealistic space of the imagination.

It all starts with a meditation with the head bowed for a long time. Move the body and gaze at the question mark on the wall. Try searching for the truth and the answer. Tear up pieces of paper moodily. When the ground is littered with absurd numbers that form the truth, the image of a pink heart appears, yet is torn into numerous bits and pieces by my own hands.

Take a sharp knife, chop the onion and radish, and mix them with the remainder of the broken heart in the proud and sparklingly crystal glass that is held high in the hand: as the long and slim metal spoon hits the inside of the crystal glass with a tinkling sound, certain essence deep in my heart undergoes a subtle change.

Concentrating all my spirit and will, I meditate on and praise "her". When her weight light as a drop of water gently seeps through my body, I put the remainder of my spirit and will in the glass into the bottomless pan brought by the maid and take out a genuine heart from it.

At the moment the heart unites with the body, the reality changes and is bathed in red light, just like in alchemy, and I begin-

To dance for infusing life into her body

To dance for the revival of her cold heart

To dance for bringing light to her heart which is translucent as glass

Till the warm pale blue light appears in the middle of her soft heart, and her body slowly whirls with my steps. The sound of cello is pressing and buoyant, its deep voice echoing in the moment full of light. At this moment, I will have her in a special way-until the end of all.

實驗劇─製造愛情的過程

Experimental theatre - The process of manufacturing love 2001

藝術家本人、動態聲光道具、佈景、大提琴手一名（馬庫斯‧凱瑟）

地點：國立杜塞道夫藝術學院 Raum 011

Artist, props with sound and lighting effect, stage setting, cellistr (Marcus Kaiser)

Place: Raum 011, Staatliche Kunstakademie Düsseldorf, Germany

長度：6分30秒 Length : 6.5 min

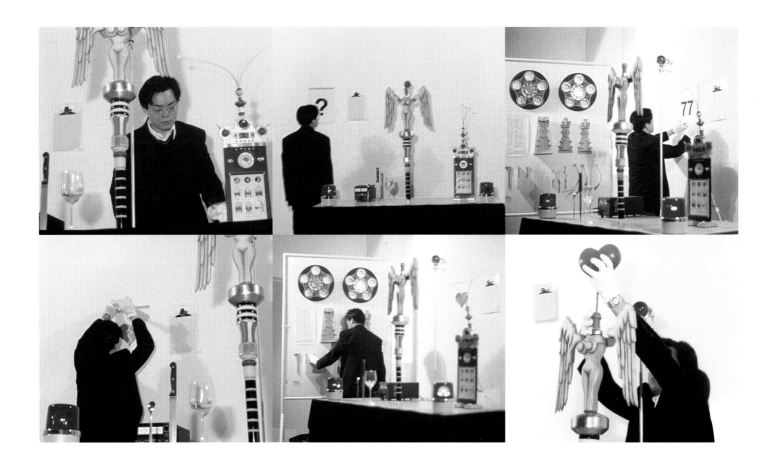

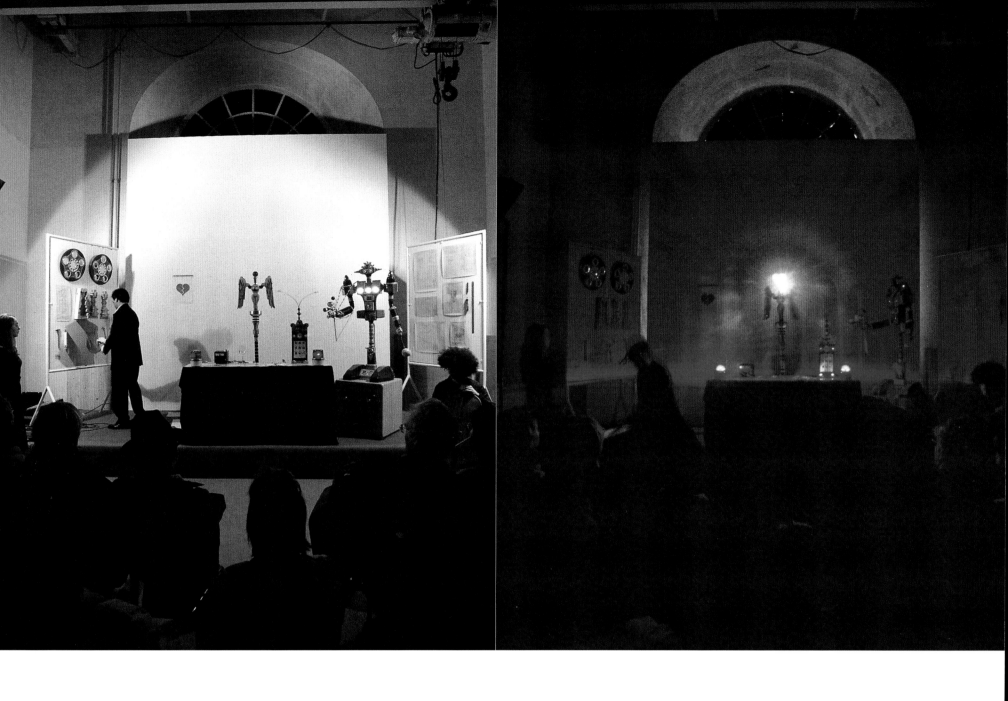

機率遊戲 **Probability Game** 2003

綜合媒材：壓克力顏料、木材、塑膠、金屬、燈、馬達、機械裝置

Mixed media : acrylic paint, wood, plastic, metal, lamp, motor,

mechanical parts

60 × 78 × 18 cm

本作品為台北誠品畫廊所有 Courtesy of the Eslite Gallery, Taipei

展開的物體結構　**Unfolded Object Structure**　2003

綜合媒材：壓克力顏料、木材、塑膠、金屬、燈、馬達、機械裝置

Mixed media: acrylic paint, wood, plastic, metal, lamp, motor,

mechanical parts

78 × 60 × 10 cm

私密的物件 **Personal Belongings** 2003
綜合媒材：壓克力顏料、木材、塑膠、金屬、燈、馬達、機械裝置、玻璃球
Mixed media: acrylic paint, wood, plastic, metal, lamp, motor,
mechanical parts, glass ball
60 × 78 × 10.5 cm
（玻璃球自作品下延伸 45 cm · glass ball suspends 45 cm from the work）
私人收藏 · 台北　Private Collection, Taipei

趣味的圖象結構　**An Interesting Pictorial Structure**　2003

綜合媒材：壓克力顏料、噴漆、紙、木板、燈

Mixed media: acrylic paint, spray paint, paper, wood panel, lamp

57.5 × 53.5 × 4 cm

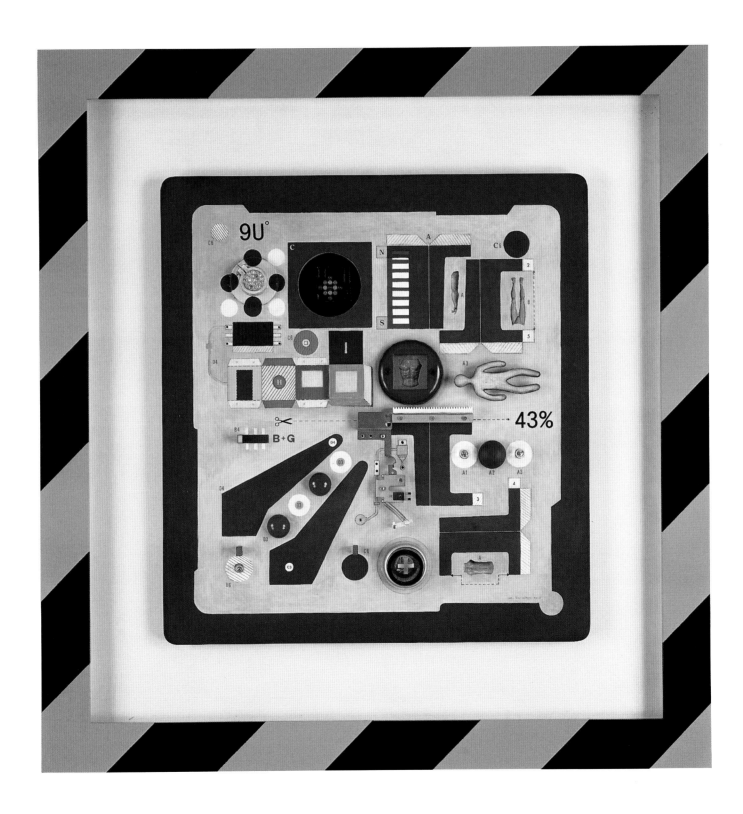

迷宮劇場 **Maze Theater** 2002

綜合媒材：壓克力顏料、噴漆、木材、塑膠、金屬、燈、馬達、機械裝置、

電子控制器（背景音樂製作：馬庫斯‧凱瑟）

Mixed media: acrylic paint, spray paint, wood, plastic, metal, lamp, motor,

mechanical parts, electronic control（Background music by Marcus Kaiser）

ø：400 / H：400 cm

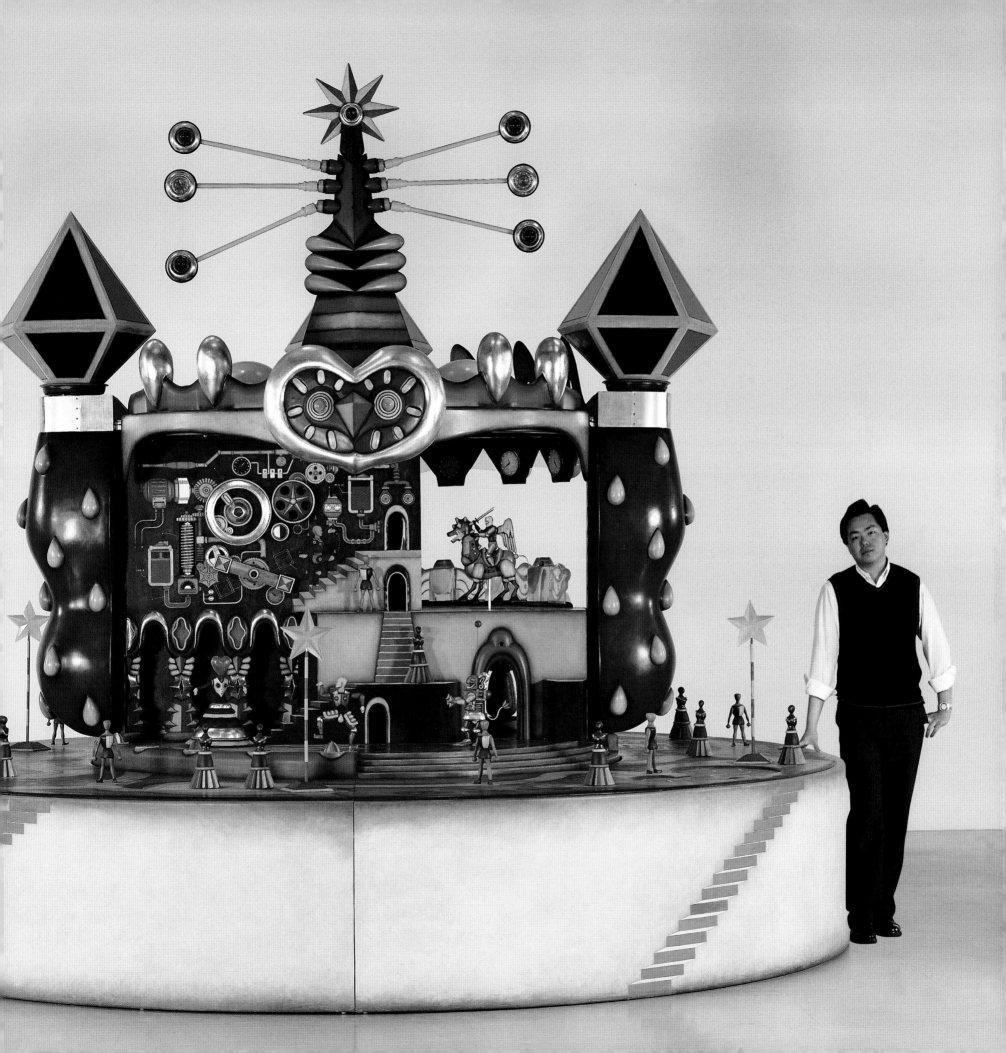

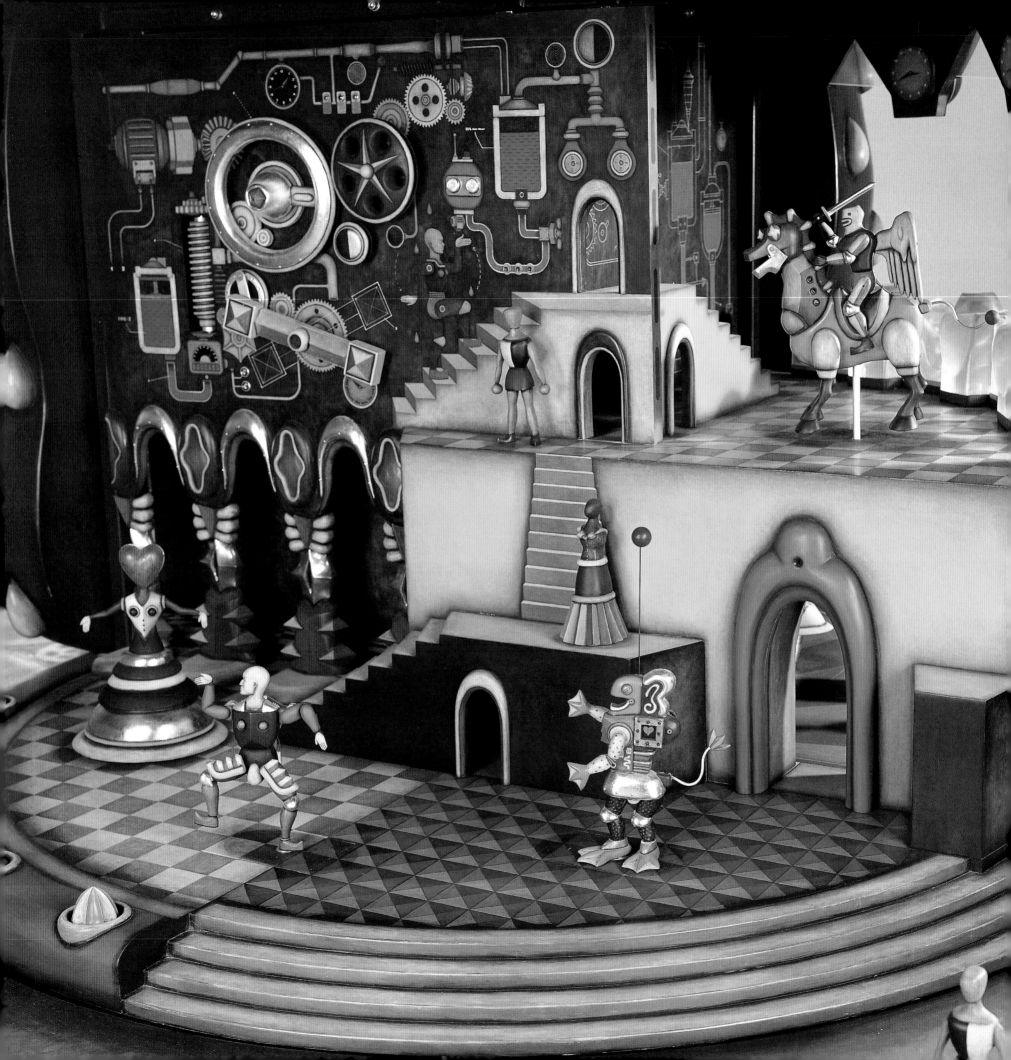

迷宮劇場─180˚ 正反轉動的馬騎士
Maze Theater - 180˚ back and forth rotation of a rider

迷宮劇場─舞台正面 **Maze Theater - Front view of the stage**（L）

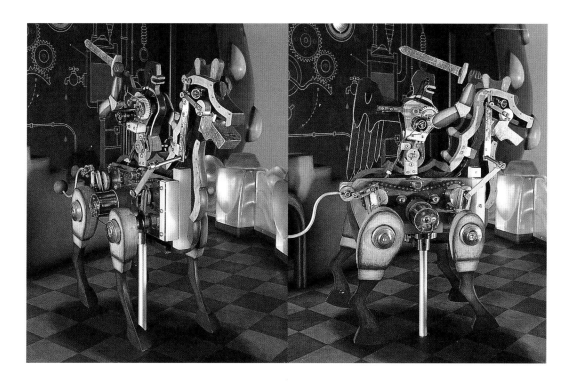

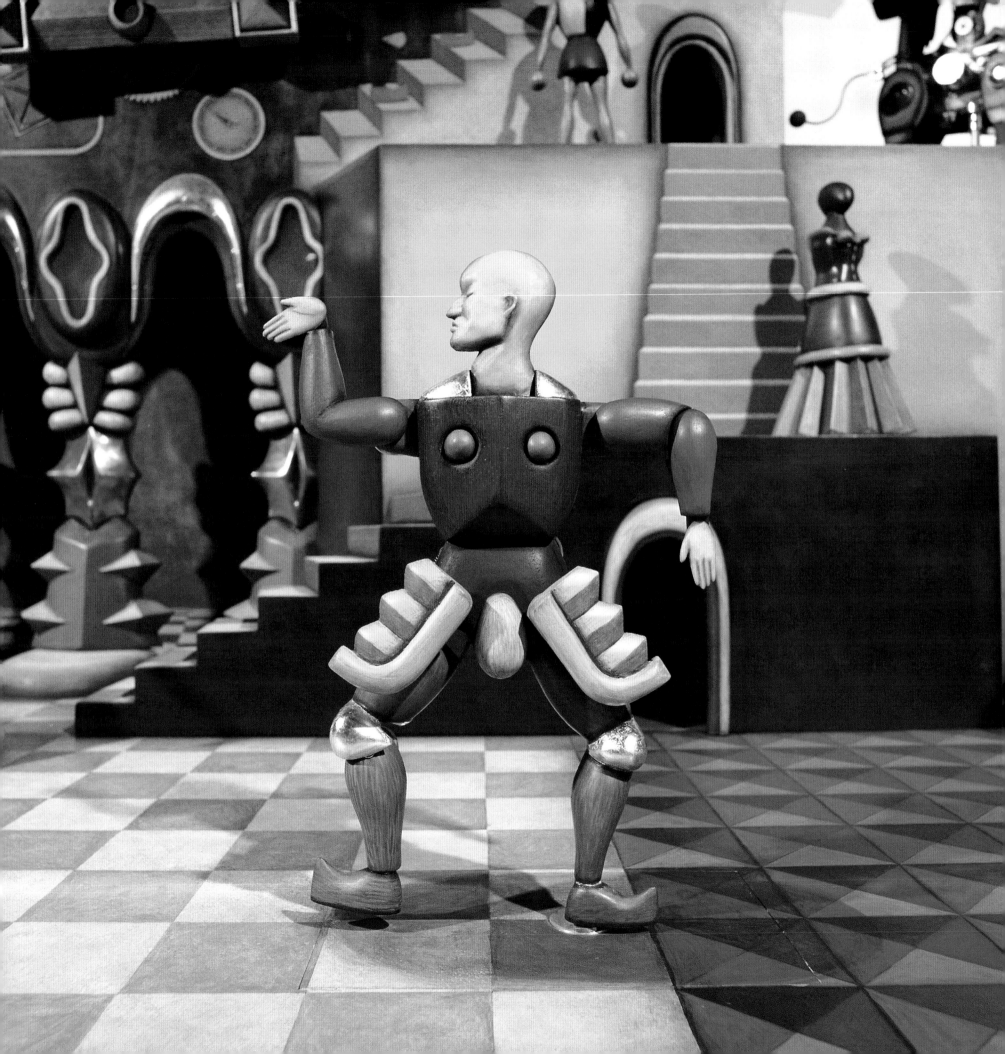

迷宮劇場— 180° 正反轉動的騎士
Maze Theater - 180° back and forth rotation of a rider

迷宮劇場—騎士局部放大　**Maze Theater - close-up detail of a rider**（L）

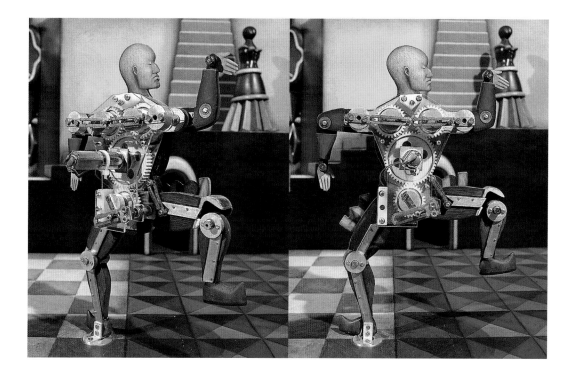

1. 迷宮劇場　草圖設計素描　**Draft sketch for "Maze Theater"**　2000

　　鉛筆、紙　Pencil, paper　29.7 × 21 cm

2. 迷宮劇場　舞台左後方　**Maze Theater - left rear part of the stage**（R）

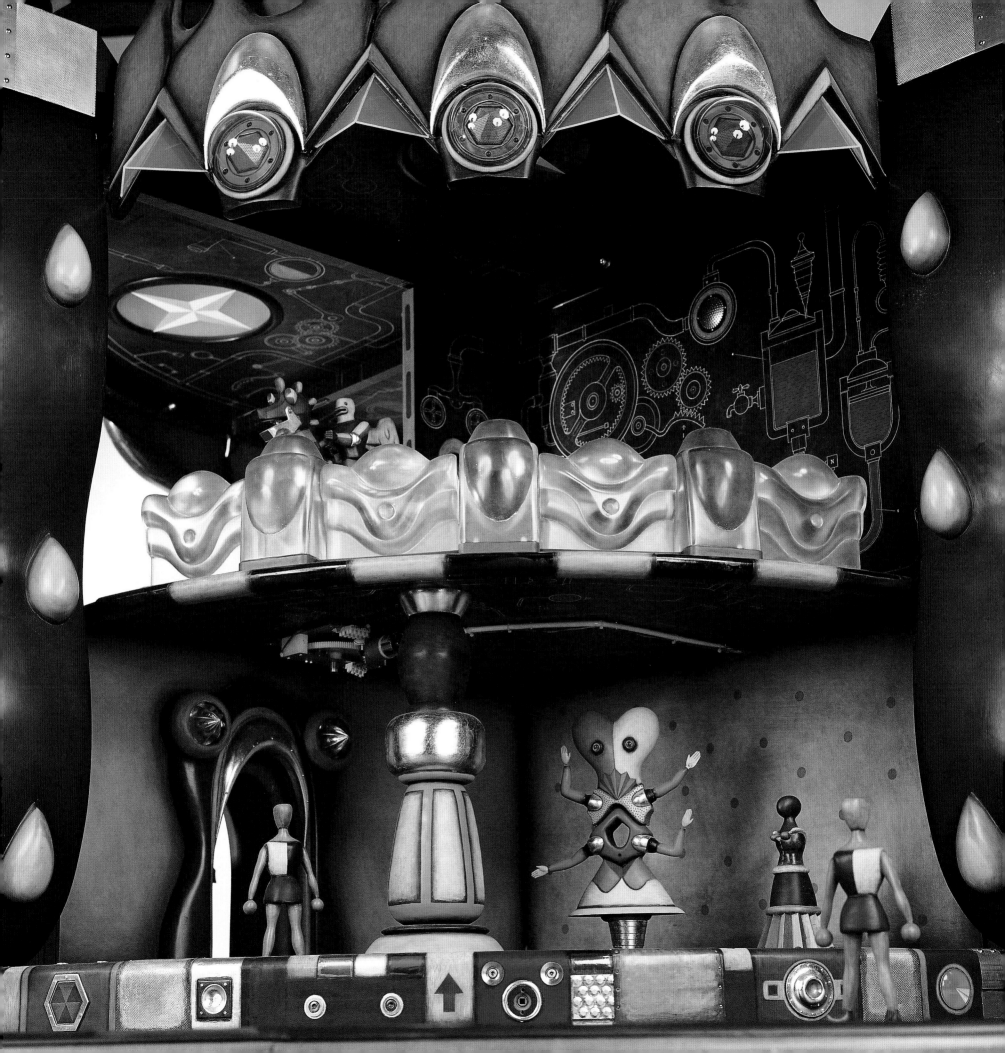

迷宮劇場— 360°動態旋轉　**Maze Theater - rotating 360°**
迷宮劇場—正後方　**Maze Theater - rear view（R）**

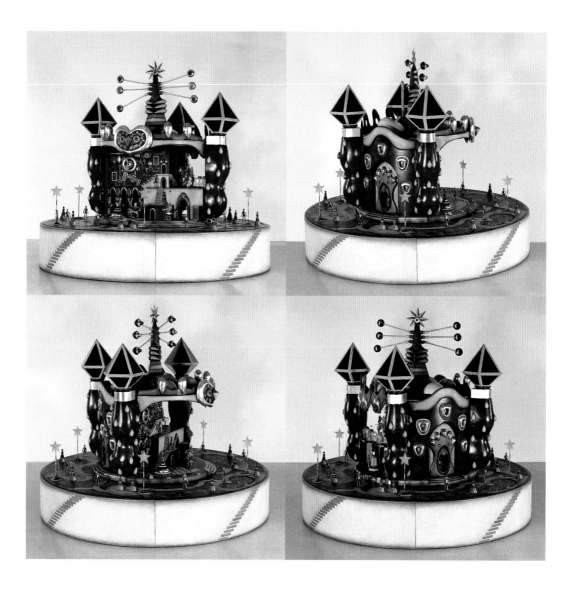

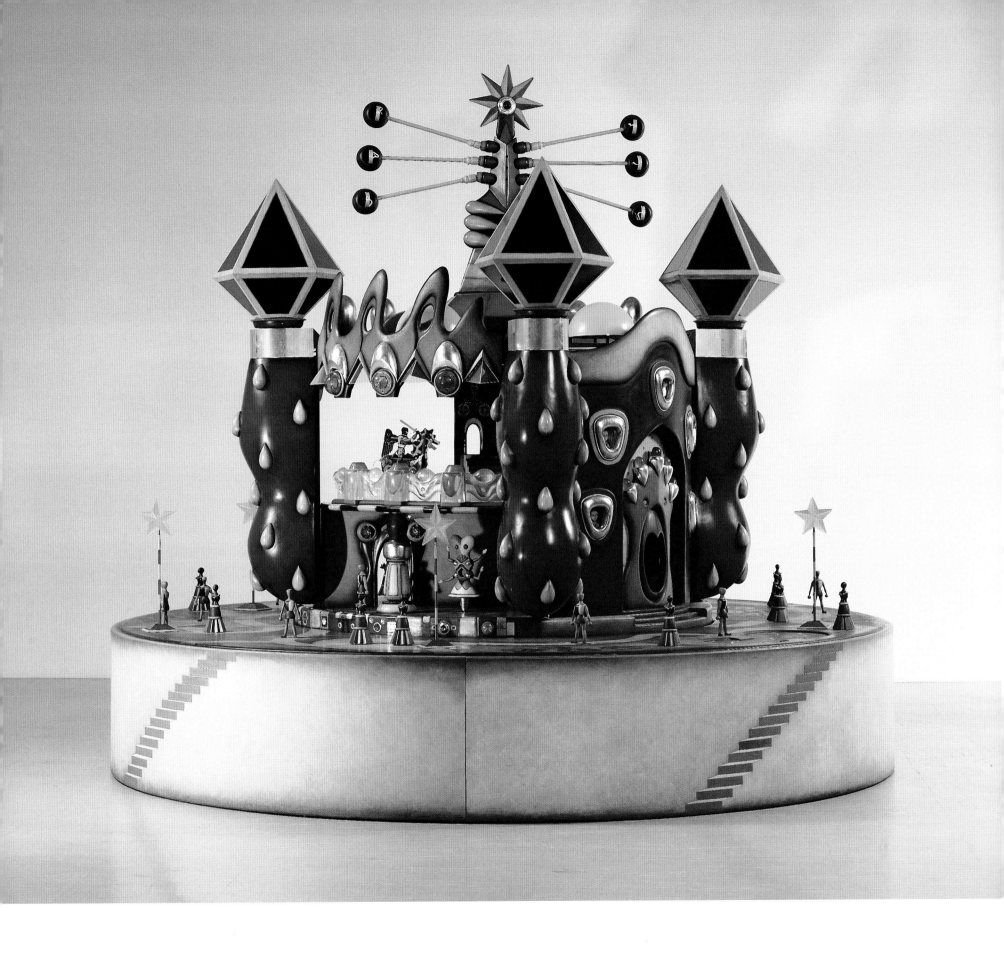

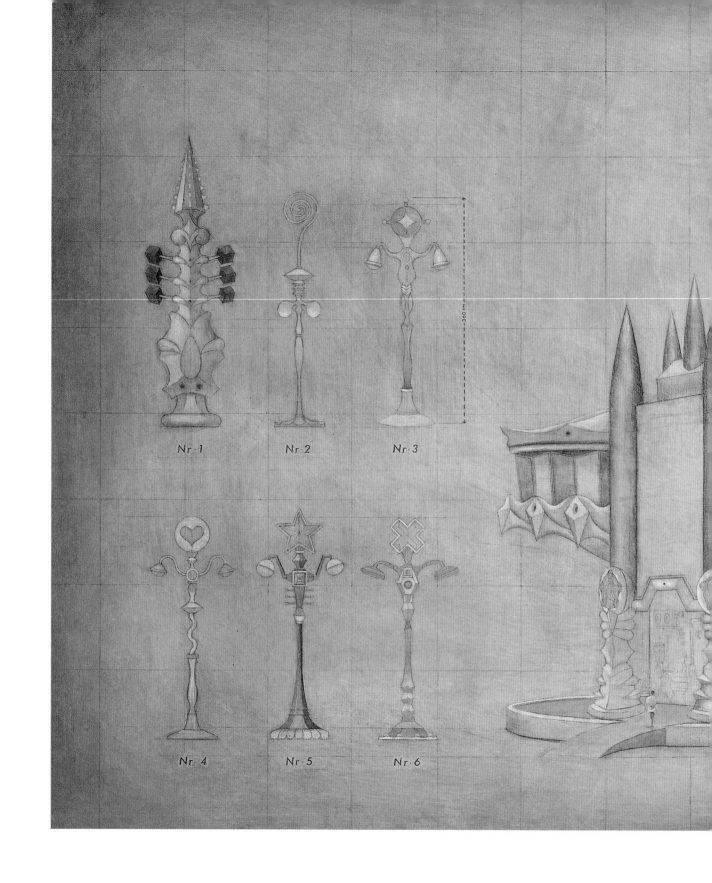

迷宮劇場　建築設計方案

Maze Theater - An Architectural Design　2004

鉛筆、壓克力顏料、木板

Pencil, acrylic paint, wood panel

100 × 207 × 4.2 cm

本作品為台北誠品畫廊所有　Courtesy of the Eslite Gallery, Taipei

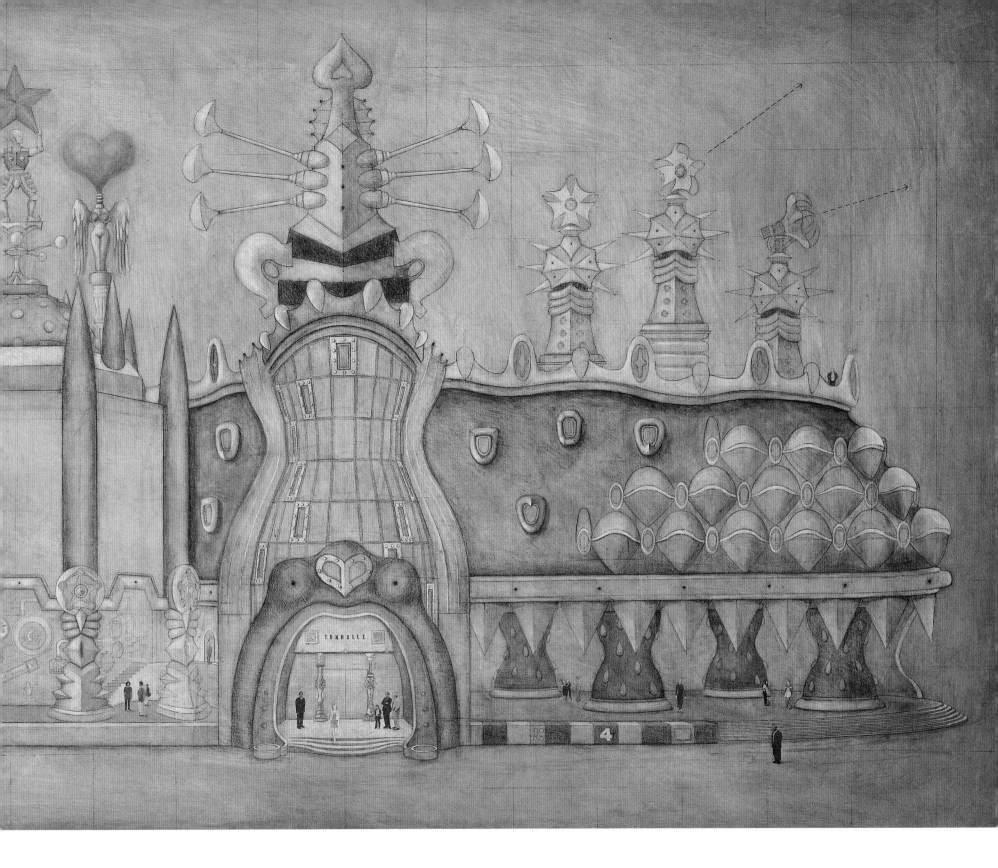

TONHALLE

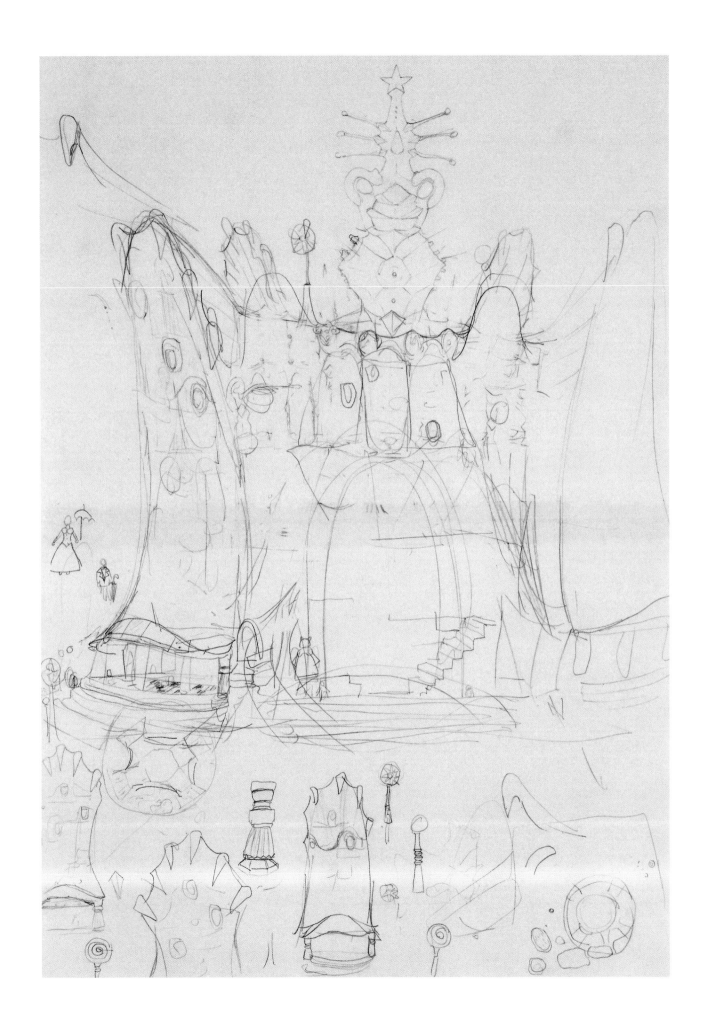

建築草圖設計素描 II（1）　**Draft sketch of architecture II**　2001
鉛筆、紙　Pencil, paper　29.7 × 21 cm
私人收藏・台北　Private Collection, Taipei

建築草圖設計素描 III（2）　**Draft sketch of architecture III**　2001
鉛筆、紙　Pencil, paper　14.5 × 20 cm
私人收藏・台北　Private Collection, Taipei

建築草圖設計素描 I　**Draft sketch of architecture I**（L）　2001
鉛筆、紙　Pencil, paper　42 × 29.7 cm
私人收藏・台北　Private Collection, Taipei

理智和感知的界線—局部放大
The boundary between sense and sensibility- detail in close-up

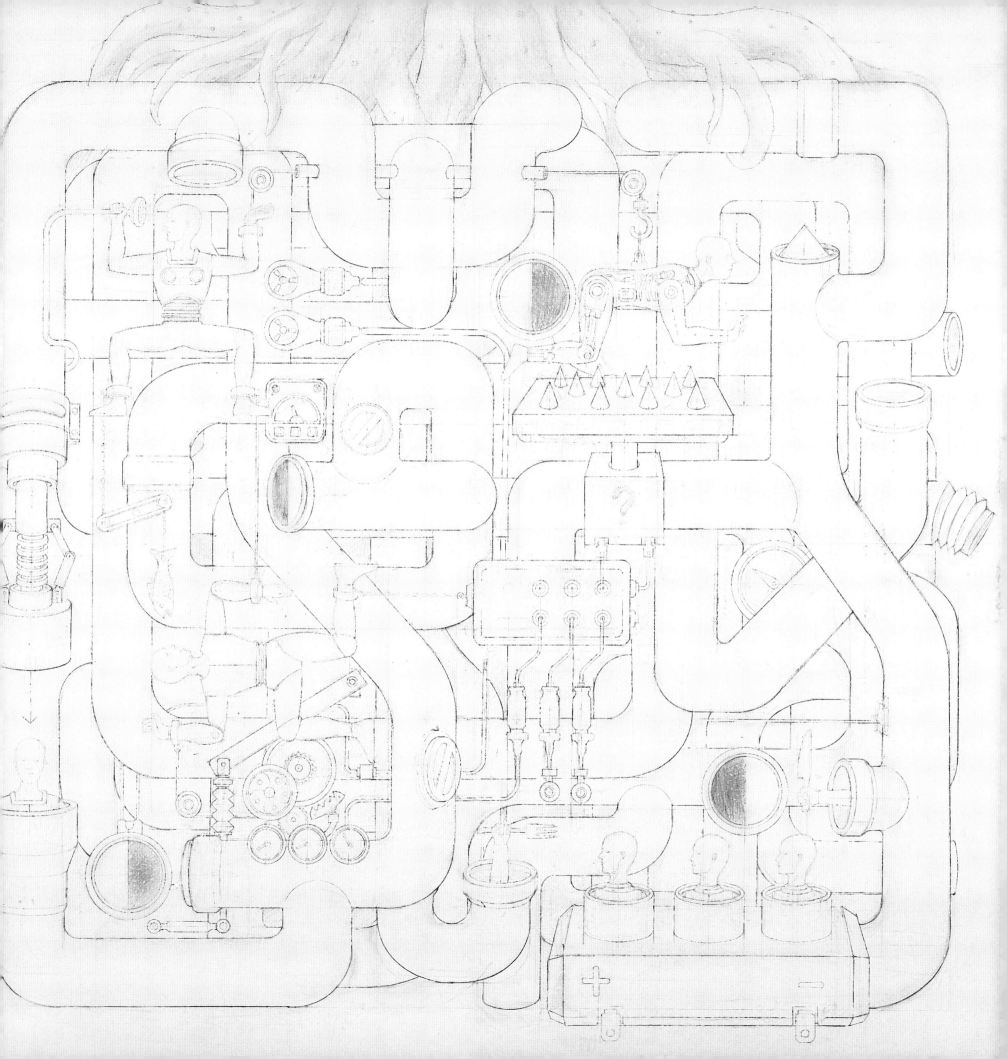

鉛筆、壓克力顏料、木板
Pencil, acrylic paint, wood panel
115 × 55 × 5 cm
私人收藏・台北　Private Collection, Taipei

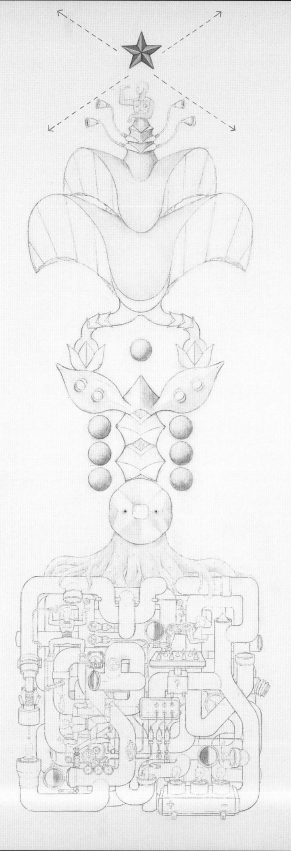

奇妙秩序　**Fabulous Order**　2002
鉛筆、壓克力顏料、木板
Pencil, acrylic paint, wood panel
三角形：每邊長110 cm，厚5 cm
Triangle: 110 cm long each side; 5 cm thick

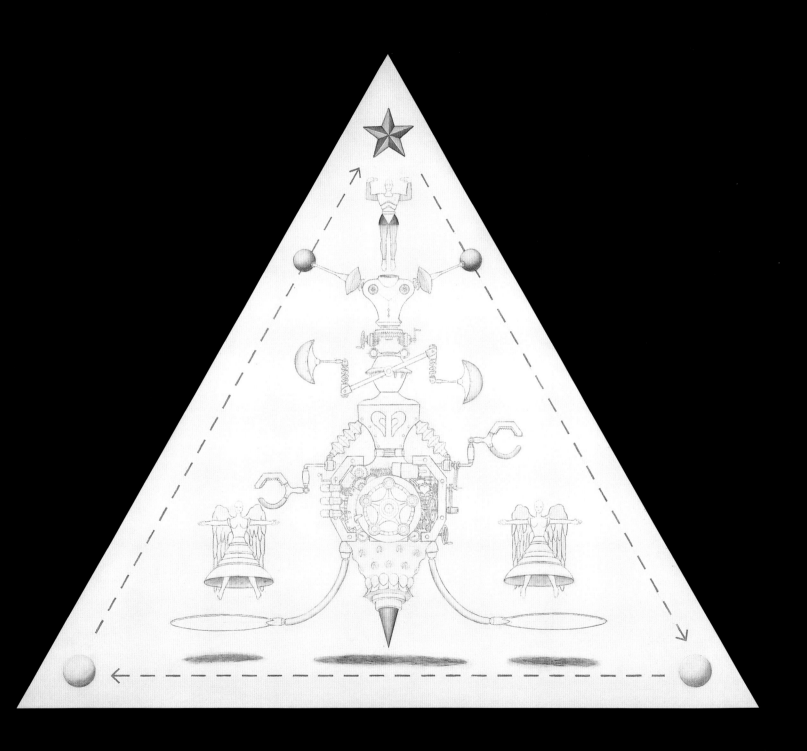

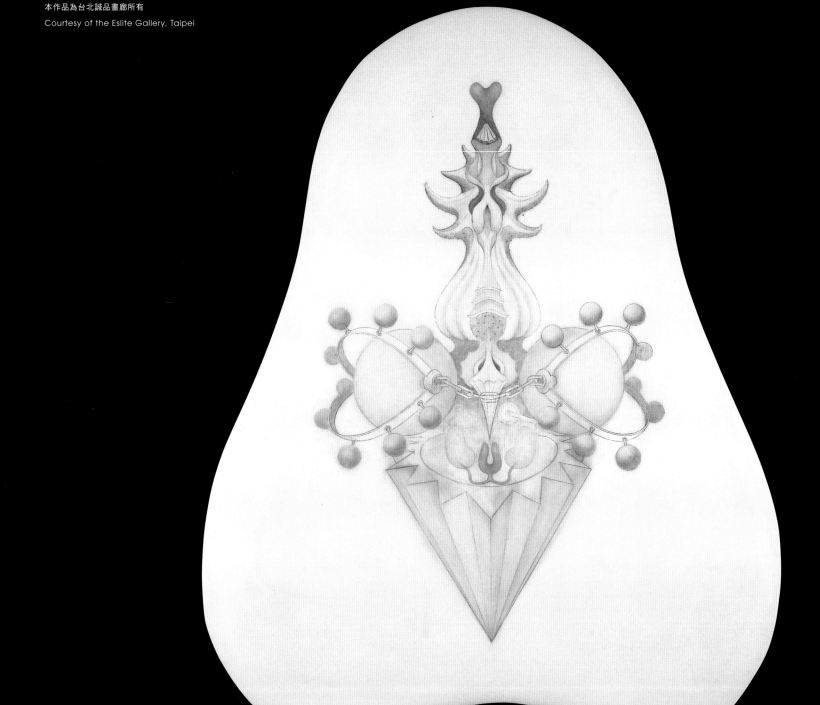

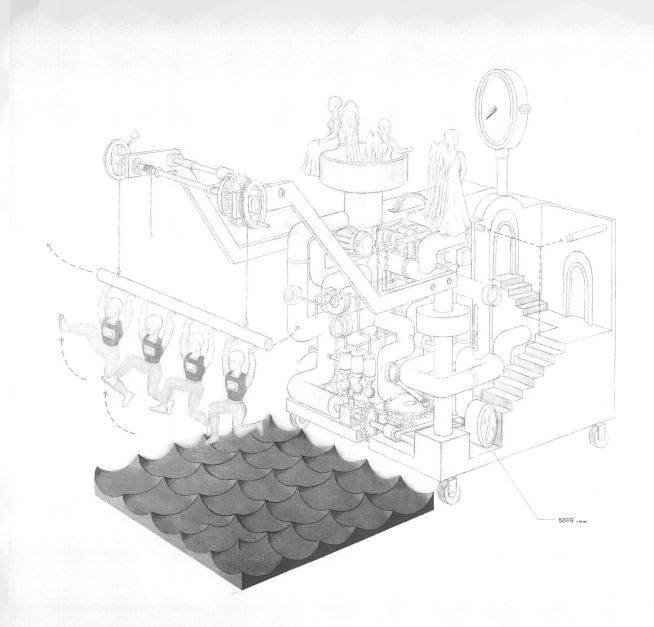

58pg

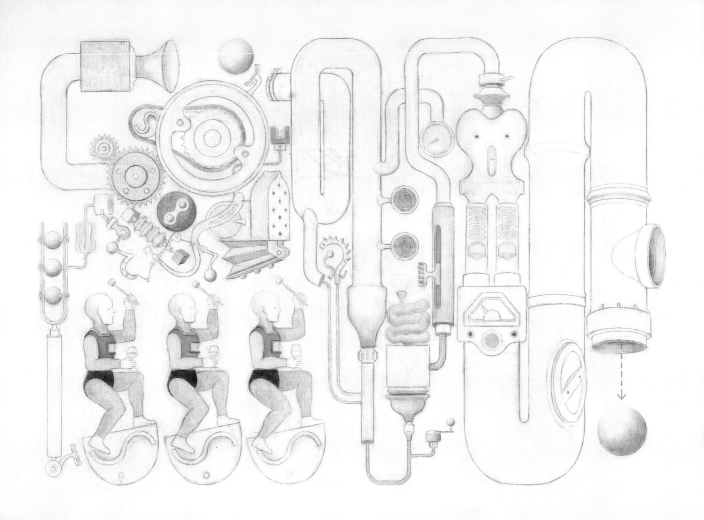

一對　**A Couple**　2004
鉛筆、壓克力顏料、木板
Pencil, Acrylic paint, Wood panel
177 × 136.5 × 1.6 cm
國立台灣美術館收藏・台中
Collection of the National Taiwan Museum
of Fine Arts, Taichung

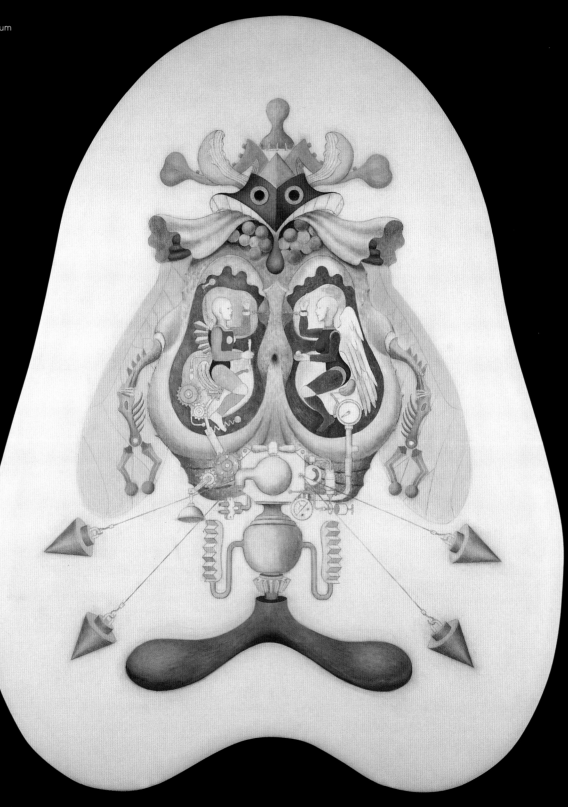

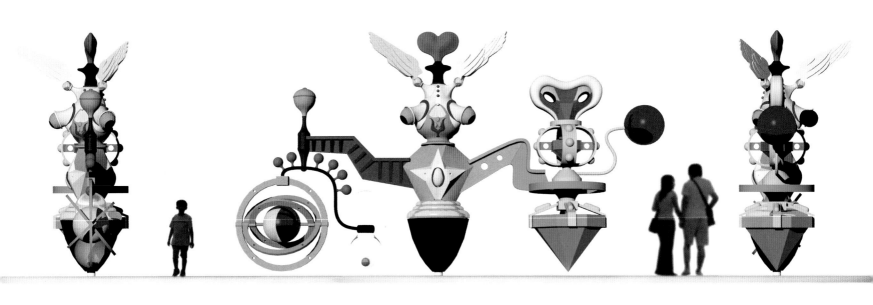

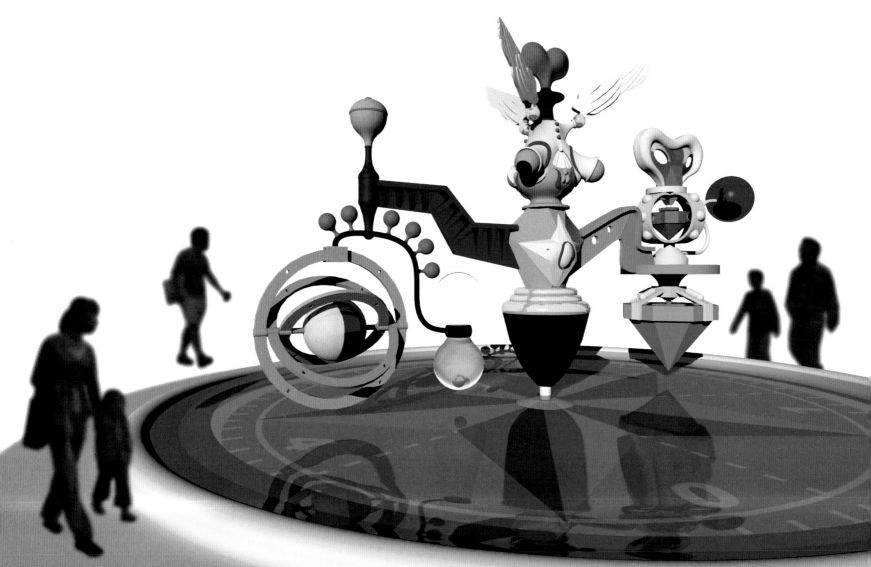

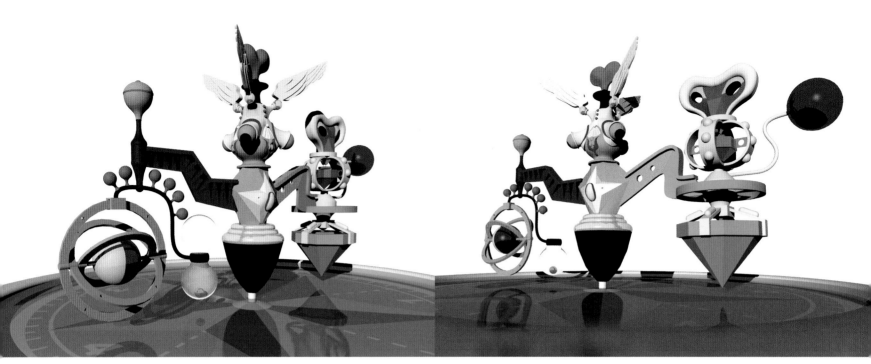
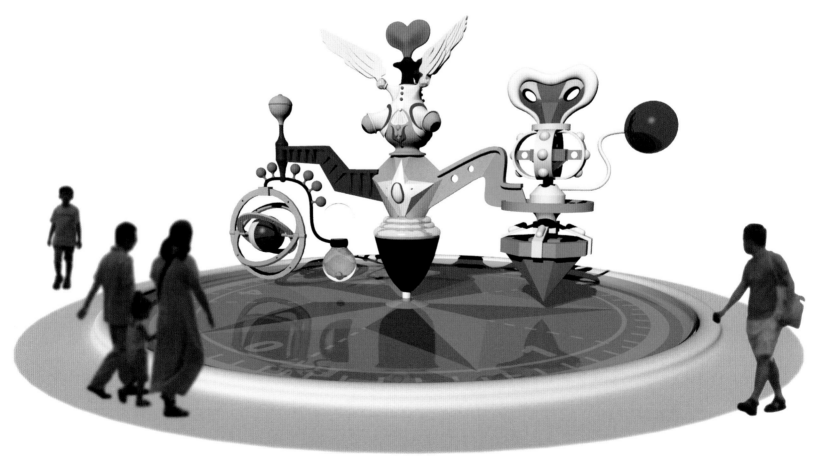

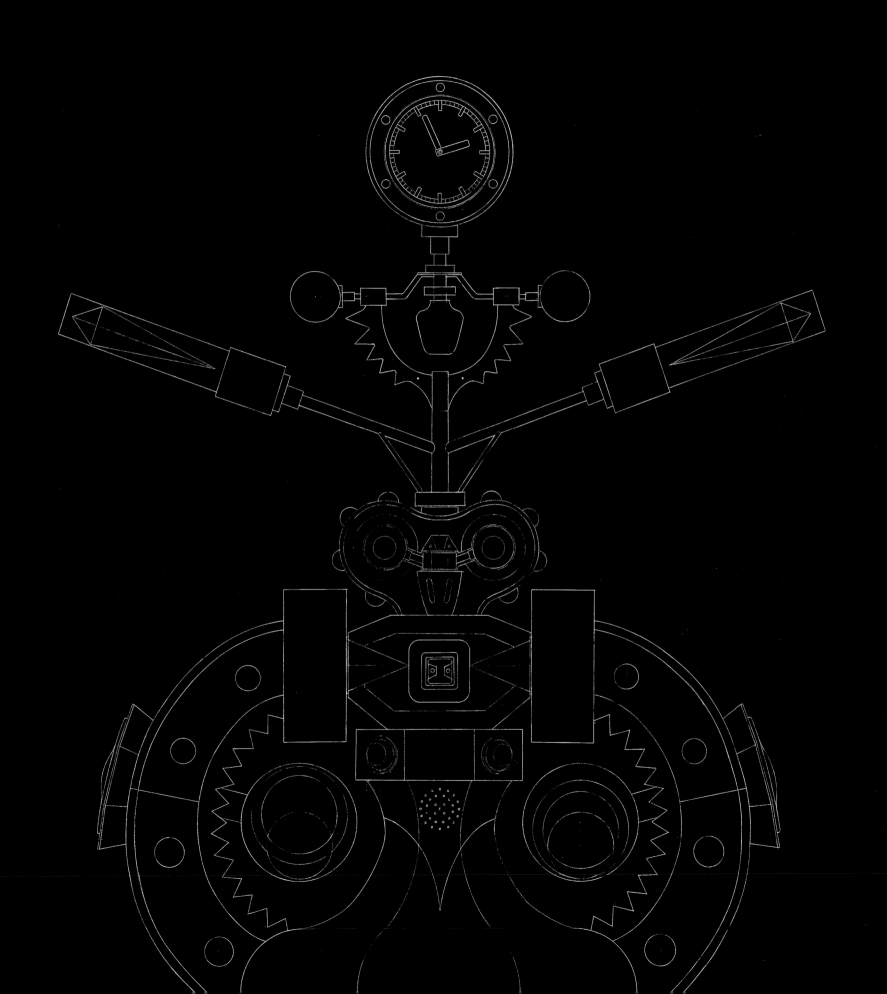

玻璃珠遊戲的秘密—局部
Mystery of the Glass Bead Game - detail
玻璃珠遊戲的秘密精密素描—局部
A fine sketch of the "Mystery of the Glass Bead Game" - detail（L）

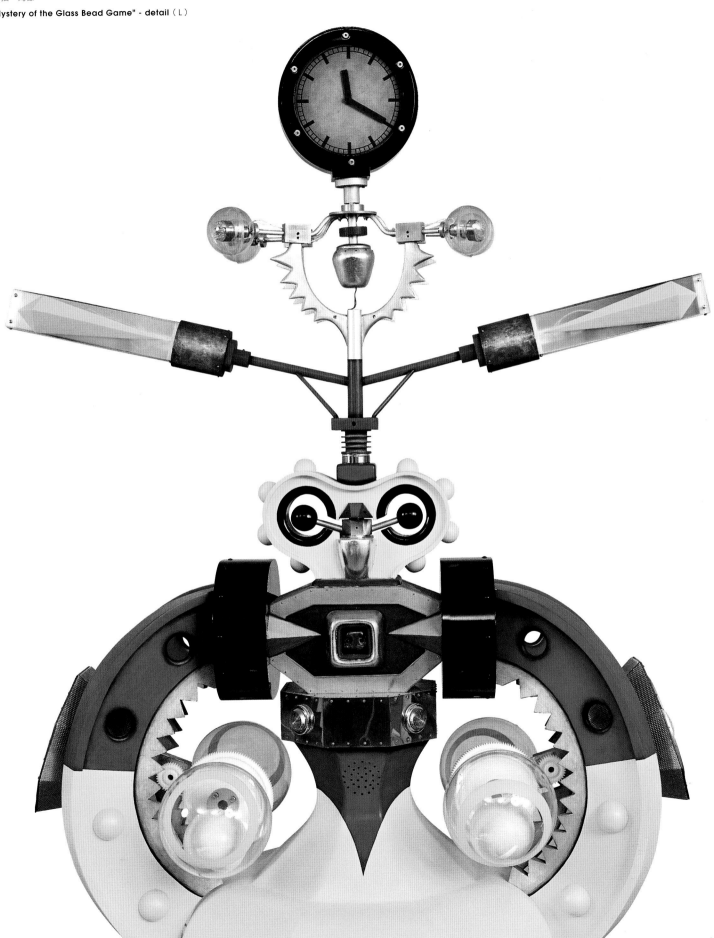

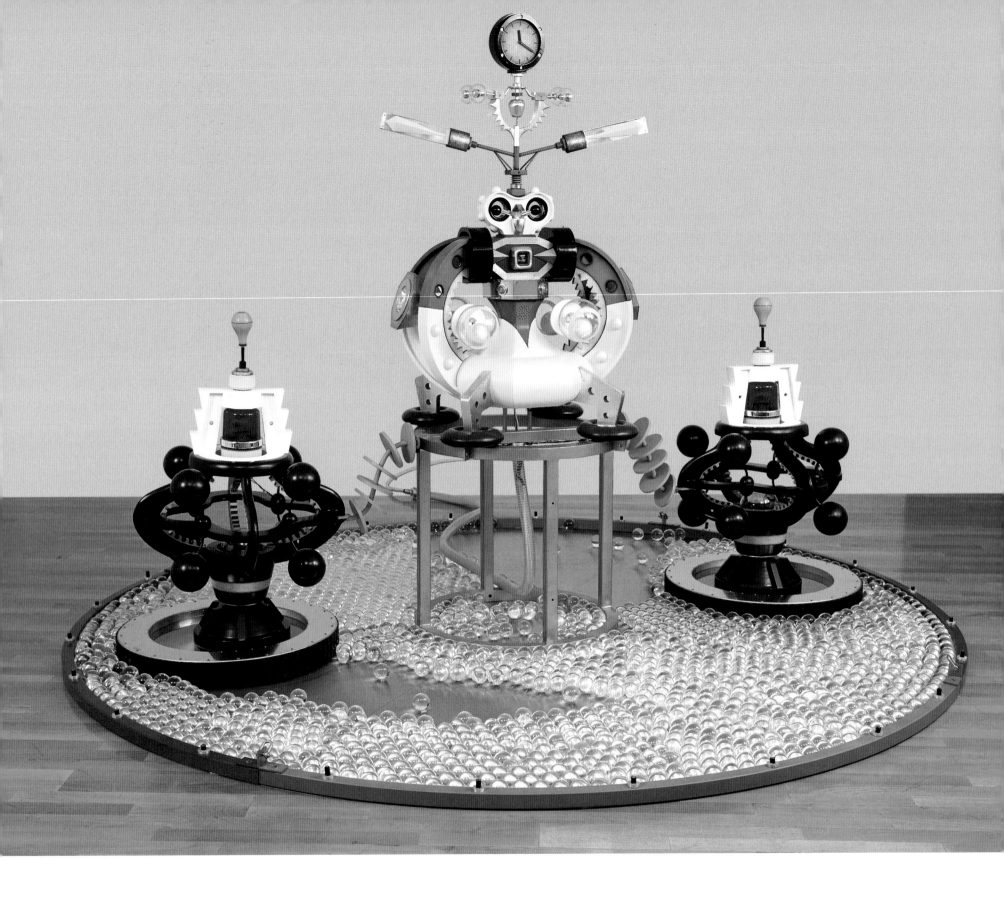

玻璃珠遊戲的秘密　**Mystery of the Glass Bead Game**　2004（L）

綜合媒材：壓克力顏料、噴漆、木材、塑膠、金屬、燈、馬達、機械裝置、

1500 顆直徑 5 公分的玻璃珠（背景音樂製作：sub-tle）

Mixed media：acrylic paint, spray paint, wood, plastic, metal, lamp,

motor, mechanical parts, 1500 glass beads－5cm in diameter

（Background music by sub-tle）

∅：300 / H：185 cm

本作品為台北誠品畫廊所有　Courtesy of the Eslite Gallery, Taipei

玻璃珠遊戲的秘密—草圖素描-1

Draft sketch of the "Mystery of the Glass Bead Game"　2003

鉛筆、紙

Pencil, paper

29.7 × 21 cm

玻璃珠遊戲的秘密—草圖素描-2

Draft sketch of the "Mystery of the Glass Bead Game"　2003

鉛筆、紙

Pencil, paper

10 × 10 cm

1

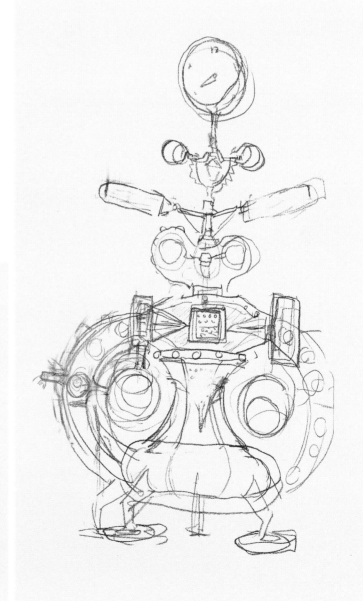

2

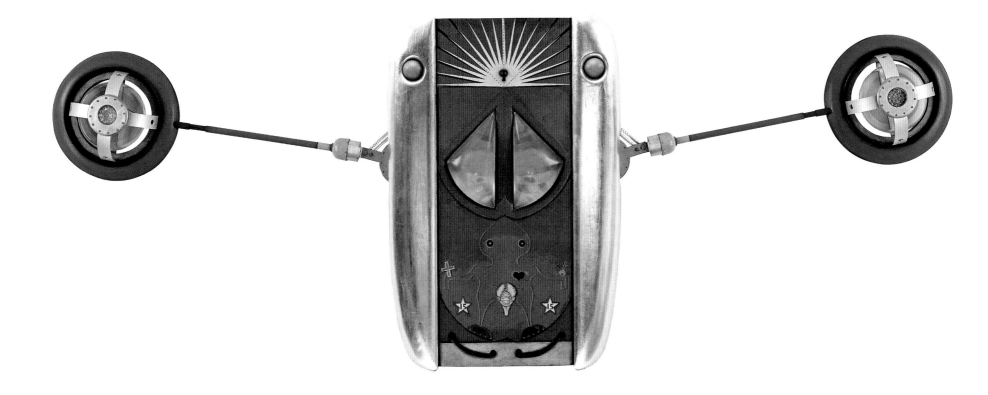

魔鬼的臉 **Devil's Face** 2003
綜合媒材：壓克力顏料、木材、塑膠、金屬、燈、馬達、機械裝置、電子控制器
Mixed media: acrylic paint, wood, plastic, metal, lamp, motor,
mechanical parts, electronic control
85 × 56 × 31 cm

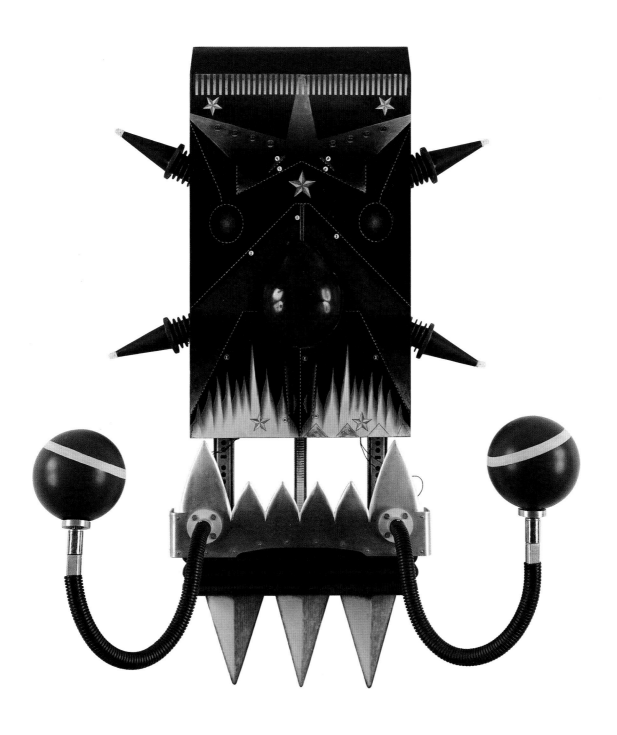

飛行器　**Flying object**　2003

綜合媒材：壓克力顏料、木板、塑膠、金屬、燈、馬達、機械裝置

Mixed media: acrylic paint, wood panel, plastic, metal, lamp,

motor, mechanical parts

39 × 28 × 12 cm

本作品為台北誠品畫廊所有　Courtesy of the Eslite Gallery, Taipei

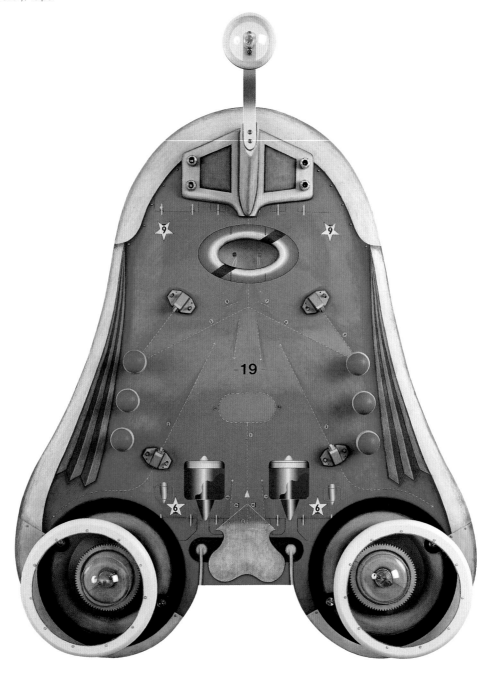

十字精神　**The Spirit of the Cross**　2003

綜合媒材：壓克力顏料、噴漆、木板、塑膠、金屬、燈

Mixed media: acrylic paint, spray paint, wood panel, plastic,

metal, lamp

33 × 25 × 55 cm（三聯作　triptych）

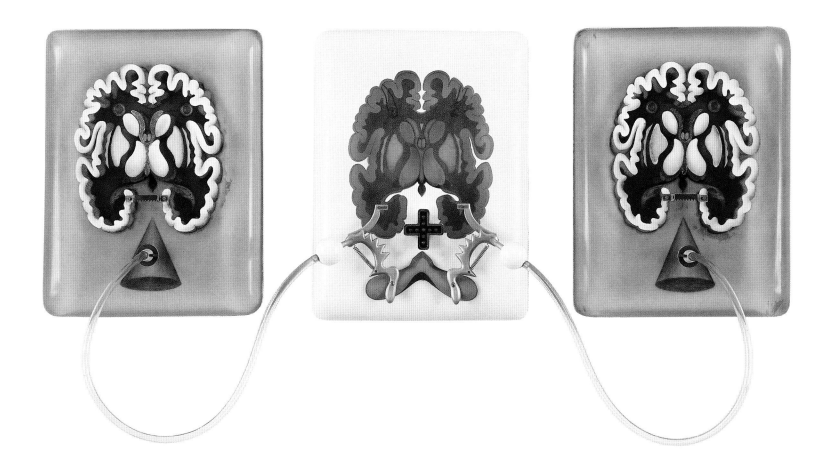

女王 **Empress** 2004

壓克力顏料、木板

Acrylic paint, wood panel

30 × 21 × 0.3 cm

私人收藏・上海　Private Collection, Shanghai

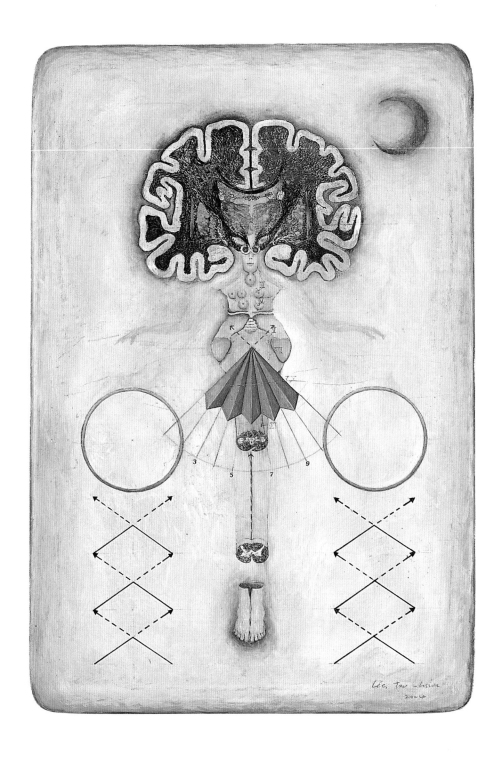

 PROCEDURE

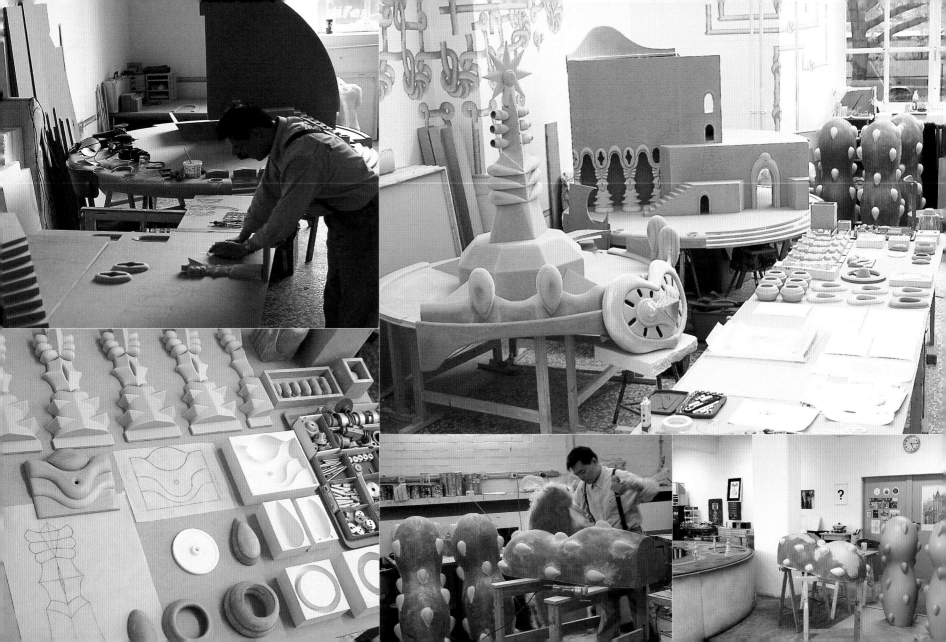

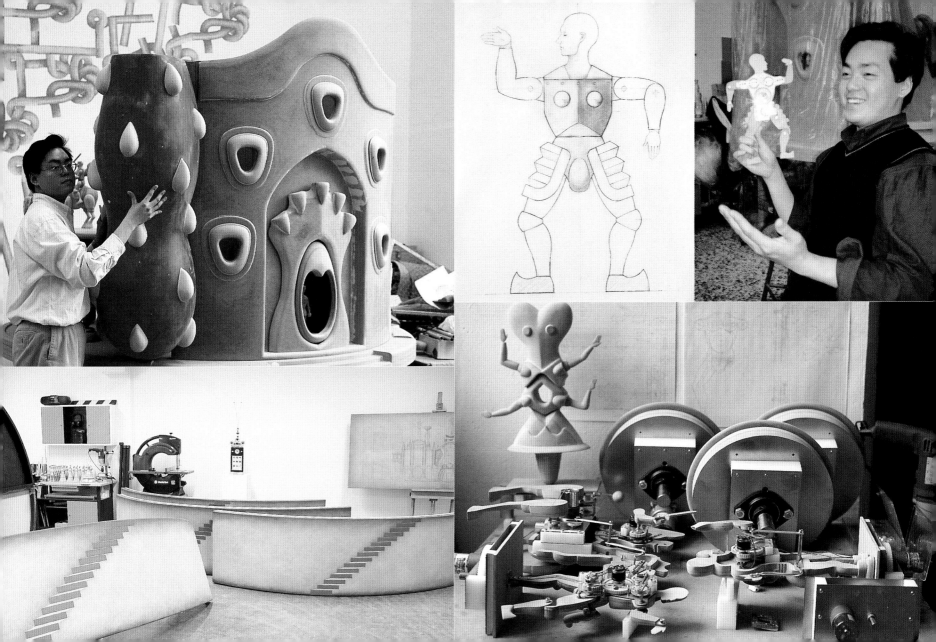

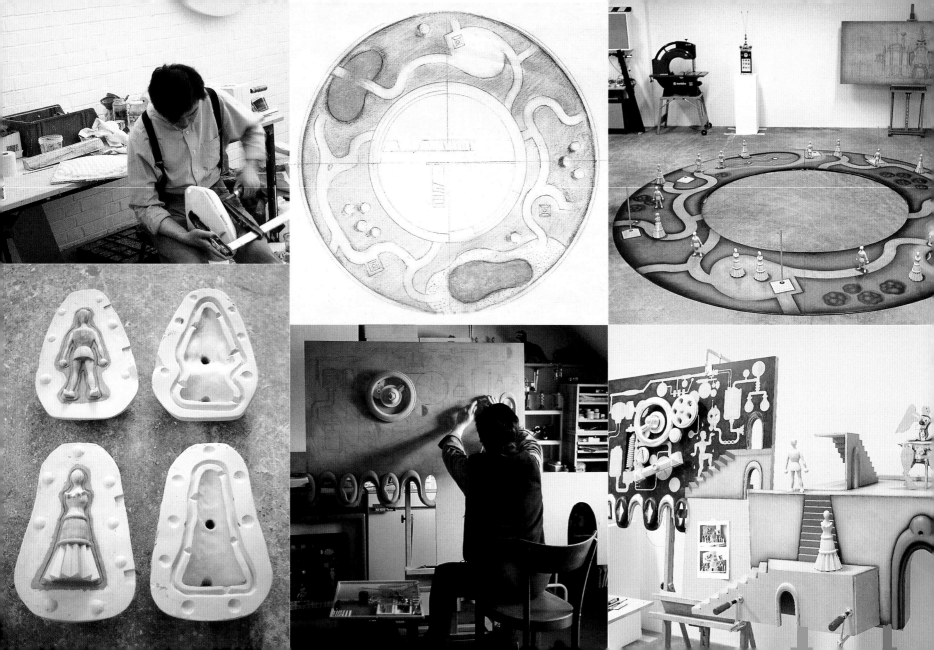

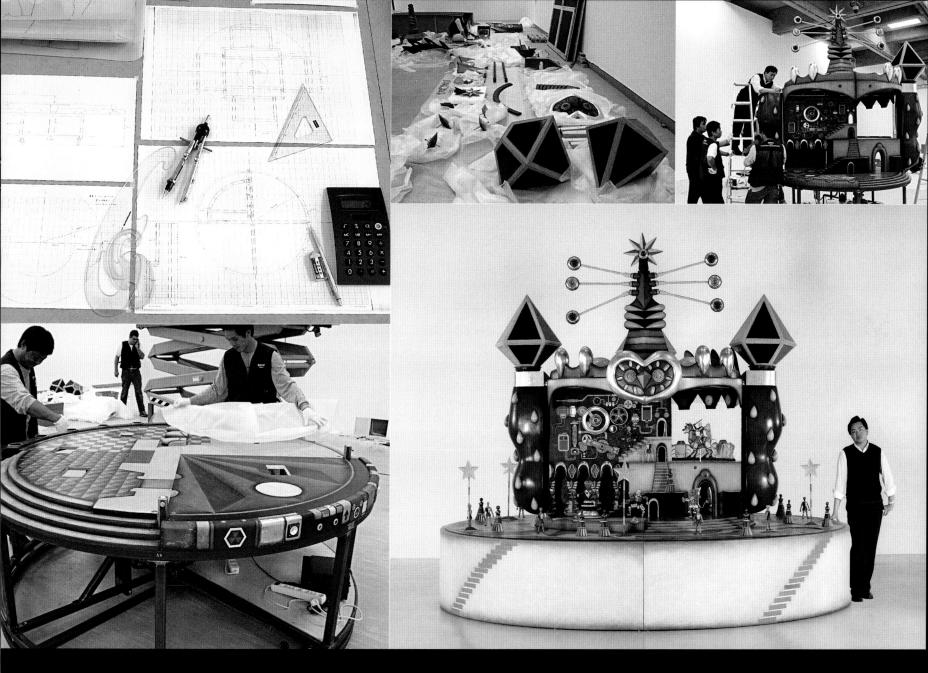

參展經歷

2005 「愛情天堂—動漫時代新美學」，上海美術館與外灘十八號創意中心、廣州廣東美術館、

北京世紀壇美術館、杭州西湖博物館，中國

「後石器時代—台灣當代年輕藝術家特展」，台北世貿中心展覽館三館，台北

2004 「玻璃珠遊戲的秘密」個展，誠品畫廊，台北

「虛擬的愛—當代新異術」，台北當代藝術館，台北

「正言世代—台灣當代視覺文化」，康乃爾大學強生美術館，美國

「三放」蘇州人文藝術會館，中國

2003 「亞洲藝術力量」，Revolver 畫廊，杜塞道夫，德國

「物體和雕塑」，哥特斯洛藝術協會，德國

「節目預告」，Schön 畫廊，波洪，德國

2002 「世界劇場—2002 台北雙年展」，台北市立美術館，台北

「歡樂迷宮—再現童年」，高雄市立美術館，高雄

2001 「Campus Thermal」，聖雷傑公園當代藝術中心，桑特儂西，法國

「製造愛情的過程」實驗劇，Raum 011，杜塞道夫藝術學院，德國

「歡樂迷宮—再現童年」，台北當代藝術館，台北

2000 「瘋人院聯展」，Artoll 實驗室，彼得堡，德國

「第 54 屆巴登美術館藝術展」，巴登美術館，舒林恩，德國

「複數元的視野—台灣當代美術 1988-1999」，高雄山美術館、新竹清華大學藝術中心

1999 「In de ban van de ring」，畢根豪夫省立美術館，哈塞特，比利時

「愛情殿堂」，杜塞道夫藝術博覽會，德國

「複數元的視野—台灣當代美術 1988-1999」，北京中國美術館、台北國立歷史博物館

1998 「大魚」，Raum 013，杜塞道夫藝術學院，德國

1997 「結餘」，杜塞道夫藝術皇宮美術館，德國

1994 「貌合神離」，台北繪畫欣賞協會，台北

1992 「聚合一刻」，天恩畫廊，永和

獲獎

2000 德國巴登美術館第 54 屆藝術展，最受歡迎獎

1999 國立杜塞道夫藝術學院，紐約旅遊獎學金

Exhibition

2005 "Paradiso d'Amore Neo- Aesthetics of Animamic Age", Shanghai Art Museum & Bund 18 Creative
Center, Guangzhou Guangdong Museum, Beijing Millennium Museum, Hangzhou West Lake
Museum, China

"The Post - Stone Age: Taiwan Contemporary Young Artists Special Exhibition", Taipei World Trade
Center Exhibition Hall 3, Taipei, Taiwan

2004 "Mystery of the Glass Bead Game", Eslite Gallery, Taipei, Taiwan (Solo Exhibition)

"Fiction · Love - Ultra New Vision in Contemporary Art", Museum of Contemporary Art, Taipei, Taiwan

"Contemporary Taiwanese Art in the Era of Contention", Herbert Johnson Museum of
Art, Cornell University, USA

"Three Persons Show", Suzhou cultural and art center, Suzhou, China

2003 "Asian Art Power", Revolver Gallery, Düsseldorf, Germany

"Objekte & Skulptur", Kunstverein Kreis Gütersloh, Gütersolh, Germany

"Trailorshow", Schön Gallery, Bochum, Germany

2002 "Great Theater of the World-2002 Taipei Biennial", Taipei Fine Arts Museum, Taipei, Taiwan

"Labyrinth of Pleasure - Childhood Revisited", Kaohsiung Museum of Fine Arts, Kaohsiung, Taiwan

2001 "Campus Thermal", Le Parc Saint Léger-Centre d'Art Contemporain, Saint- Nazaire, France

"The process of manufacturing love", Raum 011, Staatliche Kunstakademie Düsseldorf, Germany
(Performance)

"Labyrinth of Pleasure - Childhood Revisited", Museum of Contemporary Art, Taipei, Taiwan

2000 "Madhouse Labortrory Exhibition", Artoll Labor, Bedburg-Hau, Germany

"54th Bergische Kunstausstellung", Museum Baden, Solingen, Germany

"Vision of Pluralism-Contemporary Art in Taiwan, 1988-1999", National Museum of
History, Taipei,Taiwan ; Art Center of Chaotung University, Hsinju, Taiwan

1999 "In de ban van de ring", Provinciaal Centrum voor Beeldende Kunsten-Beginhof Hasselt, Belgium

"Love Temple", Art Fair , Düsselodoff, Germany

"Vision of Pluralism-Contemporary Art in Taiwan, 1988-1999", Mountain Art Museum,
Kaohsiung, Taiwan; China Art Museum, Beijing, China

1998 "Big Fish", Raum 013, staatliche kunstakademie Düsseldorf, Germany

1997 "Saldo", Museum Kunst Palast, Düsseldorf, Germany

1994 "Disagreement", Painting Appreciation Society, Taipei, Taiwan

1992 "The moment of merging", Ten-En Galley, Taipei,Taiwan

Awards

2000 Audience Award, the 54th Bergische Kunstausstellung, Museum Baden, Germany

1999 NYC Scholarship of the Staatiliche Kunstakademie Düsseldorf, Germany

國家圖書館出版品預行編目資料

迷宮劇場 / 李子勳著.
——初版.——臺北市：大塊文化, 2005〔民94〕
面；　公分. ——（tone；5）
ISBN 986-7291-43-3（平裝）

1. 藝術 - 作品集

902.2　　　　　94010792

tone 05　迷宮劇場

作者：李子勳　美術指導：李子勳　平面設計：劉信宏　攝影：劉信宏　彼安卡瑟（Bernd Glaser）

特別感謝：收藏家彭北辰、林碧蓮夫婦部分贊助

法律顧問：全理法律事務所董安丹律師

出版者：大塊文化出版股份有限公司　台北市 105 南京東路四段 25 號 11 樓　www.locuspublishing.com

讀者服務專線：0800-006689　TEL：(02) 87123898　FAX：(02) 87123897

郵撥帳號：18955675 戶名：大塊文化出版股份有限公司

總經銷：大和書報圖書股份有限公司 地址：台北縣新莊市五工五路 2 號　TEL：(02) 8990-2588（代表號）FAX：(02) 2290-1658

製版：瑞豐實業股份有限公司

初版一刷：2005 年 7 月

定價：新台幣 450 元　Printed in Taiwan